Sci-Fi Fashion
ART SCHOOL

**How to Draw Science Fiction
Characters, Styles and Action Scenes**

IRENE FLORES
AND **ASHLY RAITI**

IMPACT
CINCINNATI, OHIO
www.impact-books.com

CONTENTS

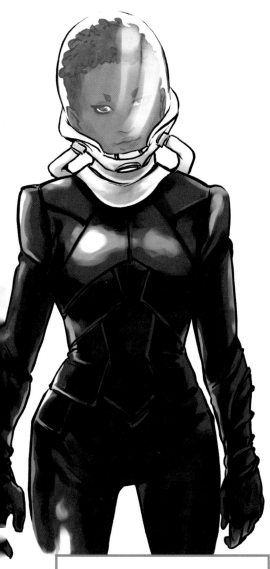

WHAT YOU NEED

SURFACE
drawing paper

DRAWING TOOLS
mechanical pencils

blue lead

gel-tip pens

felt-tip pens

brush pens

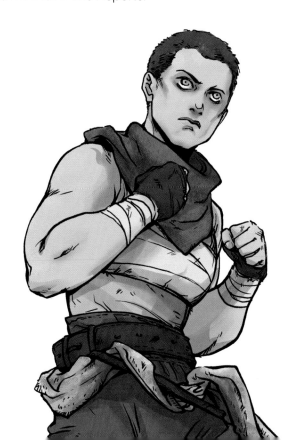

The Basics:
Tools & Techniques

Every artist is different. As you practice your skills, learn more about techniques and develop your own unique art style, experiment with different tools and figure out what works best for you. However, no matter what you draw or which art supplies you use, a good understanding of the basics will help you get to where you want to be.

Tools

Don't get overwhelmed by the huge variety of art supplies available out there. All you really need to start drawing are paper and a pen. It's OK to experiment with different supplies to find out what you prefer and what you can afford—but if you're looking for suggestions, here are a few basic tools you'll want to have on hand.

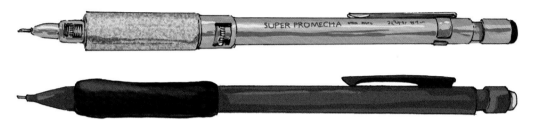

MECHANICAL PENCILS
Mechanical pencils always keep a fine point. Plus, you don't have to bother with sharpening them.

BLUE LEAD
Using blue pencil lead makes it easier to go over sketches with dark graphite or ink. Blue lead also tends to disappear when it's scanned, leaving only the darker ink behind. No need to erase all your pencil lines manually; as soon as you scan it, your art is ready for you to add digital colors!

BEFORE AND AFTER
The image on the left shows the blue-lead sketch with the inks on top. On the right, the same image has been scanned with the grayscale setting. The blue sketch lines disappear, leaving the picture ready to color with no extra cleanup.

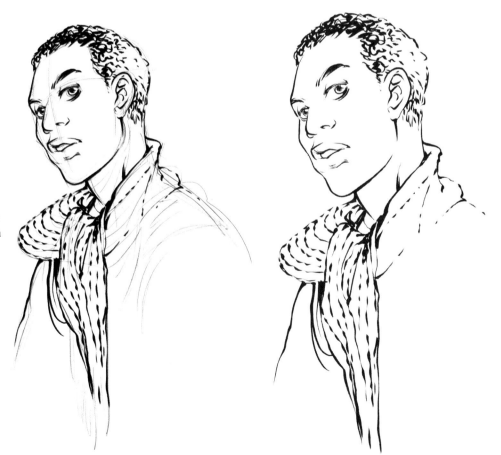

GEL AND FELT-TIP PENS

Use gel and felt-tip pens for straight lines and to fill in large areas. Trying to make lines with a brush pen and ruler can get pretty messy.

PAPER

You don't need expensive paper to draw—but depending on the pens you like, some kinds of paper will work better than others. Experiment to see what provides the best result with the tools you prefer. Deleter's Plain B paper works particularly well with brush pens because they don't bleed very much and the ink dries fast.

BRUSH PENS

These pens have a brush tip made of separate bristles, like a paintbrush. Brush pens can create lines of varying width, depending on how much pressure you apply while inking.

DIGITAL TOOLS

Take reference shots with your phone, use a drawing tablet and sketch digitally, or employ an art program to color your work. Just like traditional media such as pens and paints, digital tools are there to help you create!

Faces

A face can say so much about a character, all without a scrap of dialogue. Every person is different—from their bone structure to their blemishes to the shape of their nose. As an artist, you'll want to create characters with distinct faces that are recognizable at a glance, even in a close-up. To get to that point, though, it pays to practice the basics. At the simplest level, faces are symmetrical. Familiarize yourself with how to sketch them with symmetry guidelines and practice keeping everything in proportion.

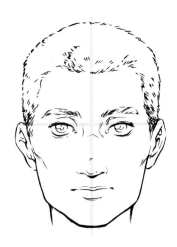
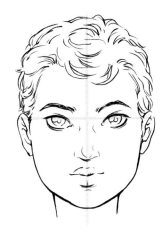

MALE VS. FEMALE FACES
There are no hard-and-fast rules about what makes a face male or female. In general, though, men's faces are drawn with sharper angles and defined jaws, while women have softer angles and more pronounced lips.

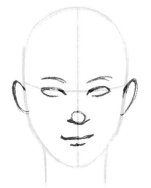
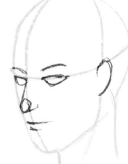
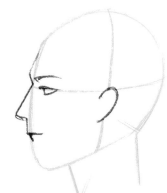

FACIAL STRUCTURE
When you're practicing how to draw a face, draw a simple guideline to help make sure the face is symmetrical. The vertical line that centers the face moves as the face changes angles, so the features should move along with it.

CHANGE IT UP
From these simple guidelines, you can create unique characters just by varying the facial features, body mass and hair. These examples show how to use your symmetry guidelines to make characters that look completely different from one another.

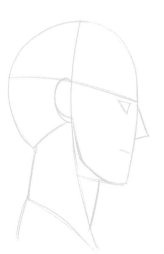
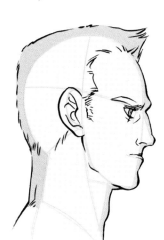
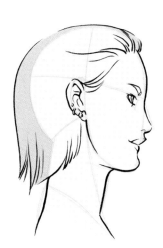

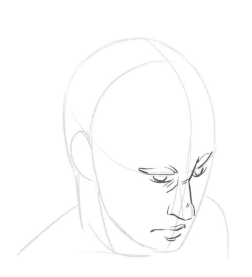
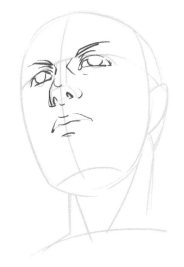
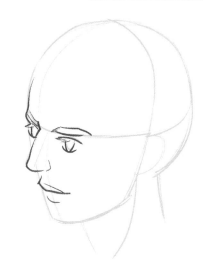

PRACTICE MAKES PERFECT

When you've got the hang of faces, practice drawing them from different angles. Rough out the structure so you know where everything goes, then try it again. The more you work at it, the better you'll get. Don't forget your guidelines!

ONCE MORE, WITH FEELING

We don't live our lives blank and expressionless. As you practice drawing faces from different angles, add some emotion. What your character is feeling can tell you a lot about them. Do they wear their heart on their sleeve or try to hide what they're feeling?

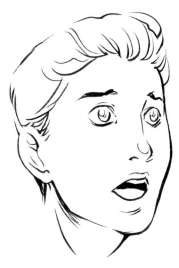
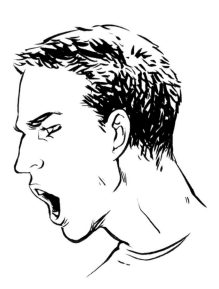
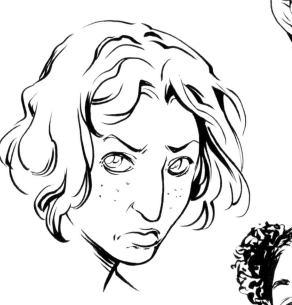
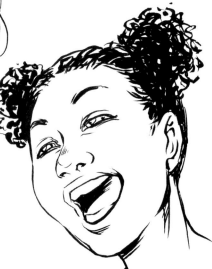
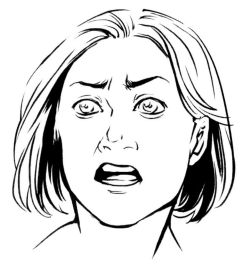

Hands

Hands are tough to draw because they're capable of doing so many things. They can hold a pencil, clap for a performance, play an instrument or swing a baseball bat. If you need help drawing a particular activity, get someone to pose while their hands perform the action you want for your character. Take reference pictures of their hands, then practice drawing from the references later.

MUSCULATURE

Understanding what's going on beneath the skin can help when you're trying to draw hands. The yellow and pink sections highlight the two main muscle groups. Look closely; the palm isn't flat, but naturally curves.

BENDS AND CURVES

On the back of the hand, the knuckles arc in a slight curve. The red lines show where the fingers bend and illustrate how they follow the curve of the knuckles.

HANDS IN ACTION

Draw hands performing any gesture you can imagine. It will help you become familiar with how they work and move. You can even use one hand to draw and the other hand as a model. Practice, practice, practice!

Feet

Feet may offer a more limited range of movement than hands, but they still take a lot of practice. Like hands, feet are capable of performing a huge range of activities like jumping, dancing, running and swimming. To draw them well in action, make sure you understand the basic shape of the foot and how it comes together.

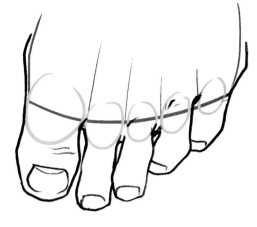

TOES

Each toe has a different shape, but like the fingers, they follow the curve of the knuckles. The second toe can be shorter or longer than the big toe, depending on the person.

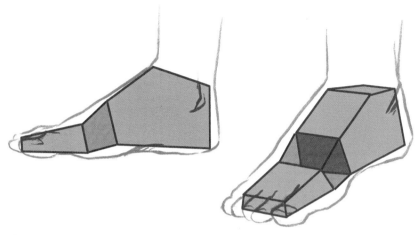

SHAPE AND MOVEMENT

Think of the foot as three different shapes joined together. The moving parts of the foot are the ankle, the toes and the center portion (outlined in purple). The heel and front pad are immobile blocks connected by that stretchy center. Keep this in mind when drawing feet that are curling, arching, walking and running.

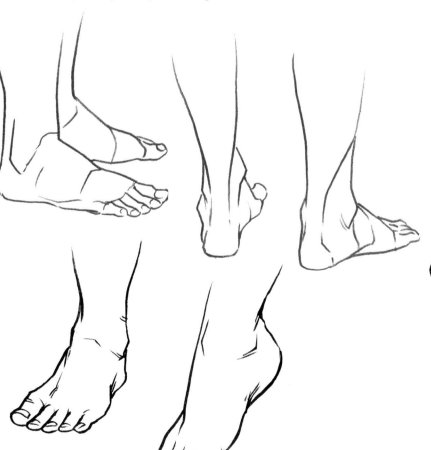

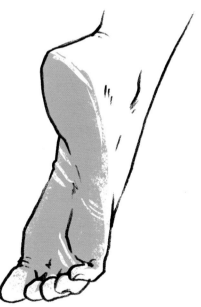

SOLE OF THE FOOT

The bottom of your foot isn't flat. Here, the pink areas show the spaces that connect with the ground, and the white areas show the ridges in between the muscles that curve inward.

Bodies

The best tool for drawing people is a good understanding of how the body works. This section should give you a start, but you can supplement your knowledge with anatomy books, observing from life or movies, and taking figure drawing classes. For more tips on how to draw the human form, check out my books *Shojo Fashion Manga Art School* and *Shojo Fashion Manga Art School: Boys*.

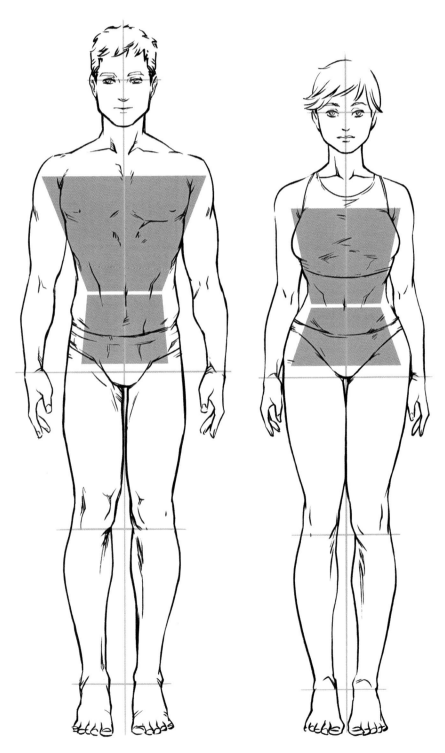

MALE-FEMALE COMPARISON

In general, men have wider shoulders and narrower hips. Women have shorter torsos, wider hips and shoulders that slope downward. These aren't set-in-stone rules, though. Think of them as general guidelines, because bodies come in all shapes and sizes.

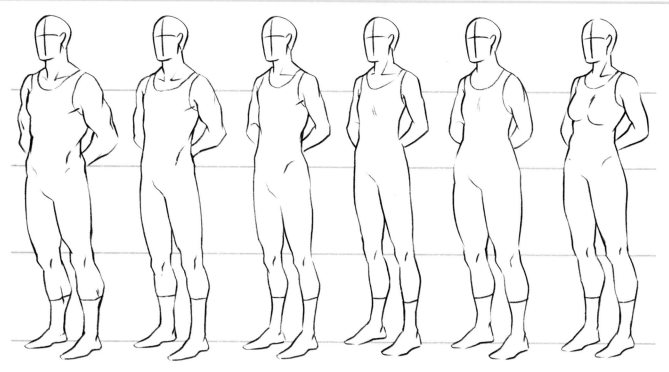

BODY TYPES

Not everyone has a perfectly "manly" or "womanly" body. Body types run the whole spectrum, and a lot of them fall in between. Much like different facial features, people can have wide or narrow hips, flat or full chests and long or stocky legs. They can be short, tall, fat or thin.

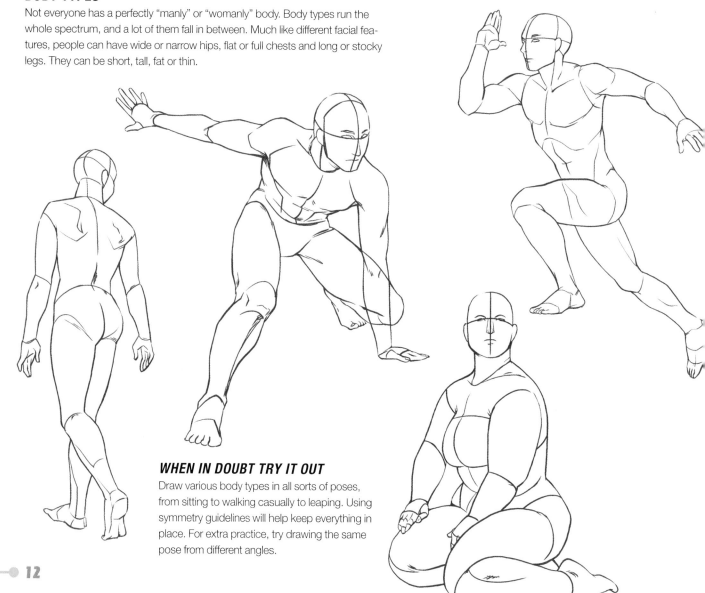

WHEN IN DOUBT TRY IT OUT

Draw various body types in all sorts of poses, from sitting to walking casually to leaping. Using symmetry guidelines will help keep everything in place. For extra practice, try drawing the same pose from different angles.

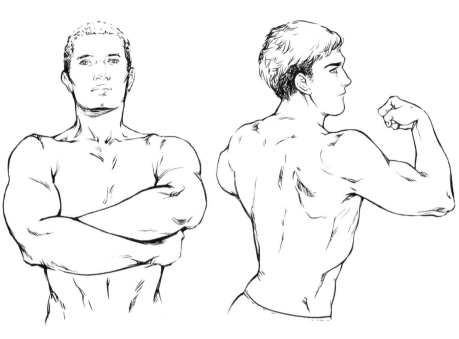

RELAXED MUSCLES

After sketching the body's guidelines, add detail. That doesn't necessarily mean a lot of muscles, though. For an average body type, this relaxed pose doesn't have a lot of muscle definition.

MUSCLES IN MOTION

When the body flexes, its muscles contract. Show definition by shading or adding small lines in the places that are more visible due to the light and shadow cast on the skin.

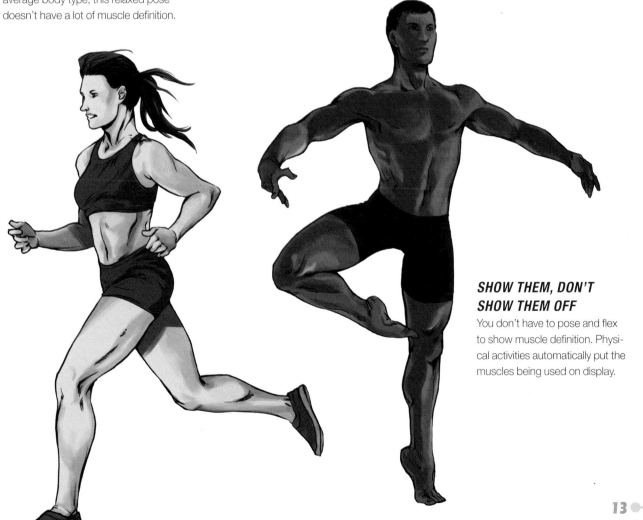

SHOW THEM, DON'T SHOW THEM OFF

You don't have to pose and flex to show muscle definition. Physical activities automatically put the muscles being used on display.

Fabric

You've got your pose. Now you're ready to start clothing your characters. Here are a few handy reminders to help you get started.

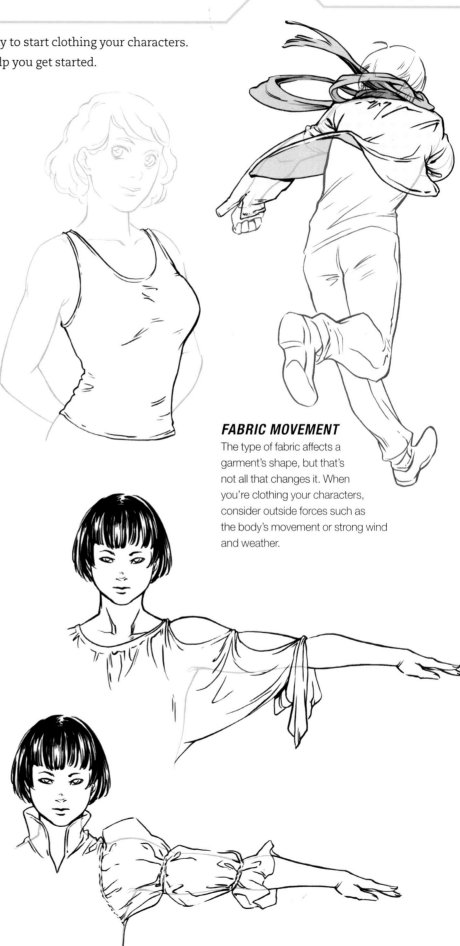

NATURAL VS. UNNATURAL FIT

Fabric doesn't naturally gather under or between breasts. If a woman is wearing a snug-fitting top, the fabric pulls down, not under.

FABRIC MOVEMENT

The type of fabric affects a garment's shape, but that's not all that changes it. When you're clothing your characters, consider outside forces such as the body's movement or strong wind and weather.

DRAPING FABRIC

All fabric is not created equal. Some materials are soft and drape on the body. Other fabrics are stiff and can hold the shape of a high collar or a bell sleeve. Fabric can also be altered by the way it's sewn. Mixing multiple fabrics can create several different drapes and textures in one garment.

Creating a Color Palette

A color palette is the range of colors used in visual art. Choosing a palette before you start coloring helps hold the narrative together by making your characters and places look like they all share the same tones, shadows and lighting.

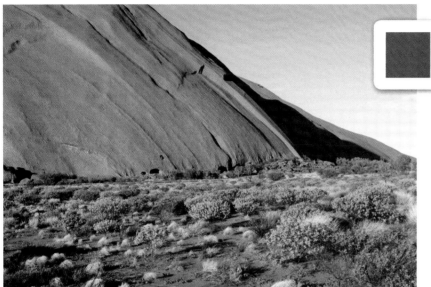

CHOOSE YOUR MAIN COLORS

Choose a few main colors from your reference photo to create a color palette. Try to include a light color, midtones and a darker shadow tone.

Now you can work from this palette to color your own desert setting and the characters within it.

PRACTICE BY USING PHOTOS

If you look closely at this desert image, you'll see that it isn't just brown. It has shades of orange, tan and chocolate. The shadows are a very dark purple, and the sky is bright blue.

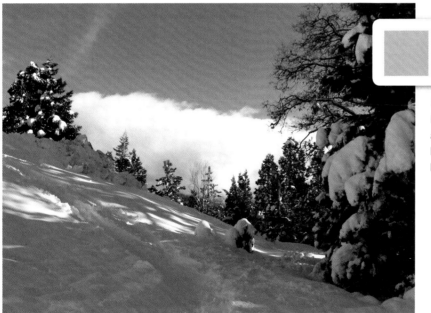

SNOW AND SKY PALETTE

Here, the palette is based on only the snow and sky. It focuses on a variety of cooler hues so you can use it to create a winter landscape.

LIMITED PALETTE

The white snow in this scene isn't just white. There are different shades of blue and gray. Note that even though the trees are green, their shadows have a blue-gray cast to them.

ADDING COLOR

So you have a beautiful, finished piece of line art. Maybe you're done—or maybe you want to take it a step further and add some personality with color. Whether you choose to color digitally or work with traditional media, the same principles apply. Use whatever you feel most comfortable with.

1 PREP YOUR LINE ART
Get your inks finished and ready for color. Some spots will have thicker lines and black areas to add depth. Or, if you'd rather, you can use thinner ink lines and add shadows when you color. It all depends on your drawing style and how you approach your line art.

2 SELECT A COLOR PALETTE
You can base a character's color palette on many things. Is the character flamboyant, preferring loud patterns? Does she have to wear a uniform with specific colors? For this particular demonstration, we'll use mostly neutral tones with a few brighter colors for contrast.

3 FILL IN FLAT COLORS
Start with a flat layer and fill in your line art with no shading. Use colors based on your color palette; it's OK to swap in variations, like a bright purple for the lines of her pants, or a bit of gray for the purple on her shirt. Just make sure that everything is based on the five colors you chose for your main color palette.

4 WORK IN LIGHT AND SHADOW

Choose a light source and start adding shadows. In this case, the light source is coming from the right, so the shadows are cast on the left. Using the flat color as a base, add a darker shade to create your shadows; on the paler parts of the garment, they show as light purple. The shadows aren't very deep yet, so it looks like the figure is someplace with quite a bit of light.

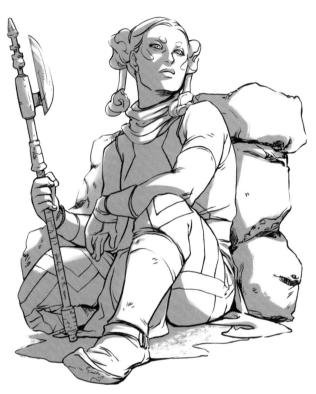

5 CHECK THE SHADOW HUE

This image shows only the line art and the shadows that will be added. In real life, shadows aren't just black or gray. They might be dark browns, greens or blues. Here, the shadows are layered in purple to match the color palette. As you build up shadows, make sure they match the overall color scheme of your art.

6 ADD FINISHING TOUCHES

Add your last layer of shadow. In this example, the deeper shadow hints at less light all around and a single light source from the right. Replace some of the black ink lines with a colored outline if you like, such as the line for the white tattoos on her face. You can also add more detail, like the gold lines on her pants or the metallic sheen on her bracelets and hair pieces.

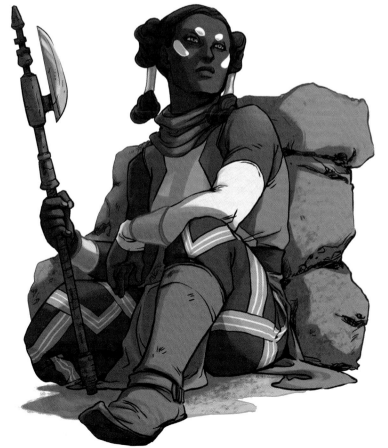

2 *The Wasteland*

Once, this world was Earth as we know it today. Then along came some disaster of monumental proportions and swept all that aside. Now the wasteland is all that's left. Clean food and water is scarce. Life is hard, and inhabitants learn how to live under their own power—or die. Every now and then, glimpses of a happier past are visible buried in the post-apocalyptic scenery, but that's all they are—memories.

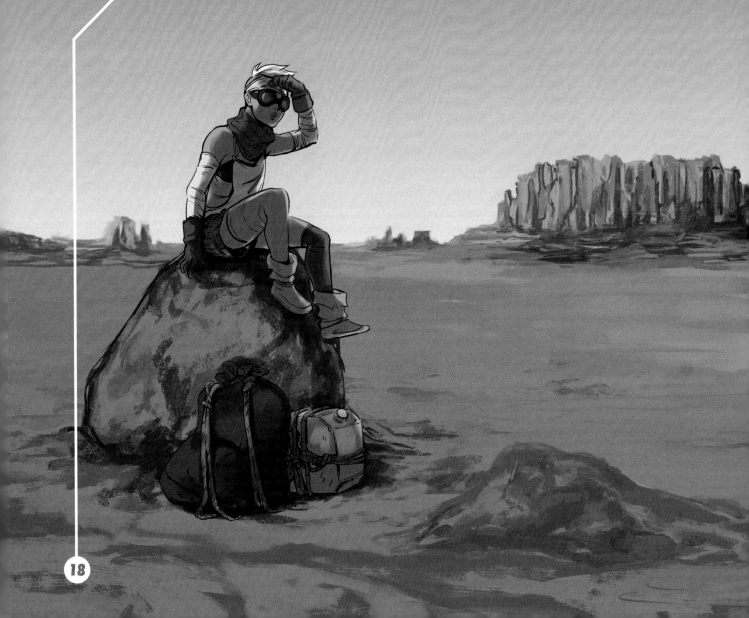

Hair

In a post-apocalyptic setting, nothing is clean or pristine. Hairstyles tend toward the short, scruffy and utilitarian. While you're designing your characters, ask yourself whether they have access to water for grooming, or even a comb. Do they care how their hair looks? Do they spend time to make it presentable?

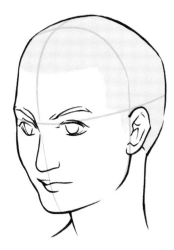

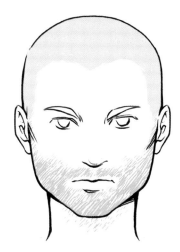

HAIRLINES

To get started, draw the head and then determine the hairline. Placement varies; you can set it lower or higher on the forehead. For older characters, you can set it even farther back to give them a receding hairline.

FACIAL HAIR

Keep in mind the places facial hair grows and the various possibilities for styling. When you're designing the look of a male character, facial hair can be long or short and groomed or unkempt. It can even be shaved into patterns.

HAIR GROWTH

The area in blue illustrates where her hair will grow in.

SHORT AND SPARSE

Use simple dots and dashes to show sparse hair. People with wavy and curly hair will have a slight curl to their hair even on short strands.

STUBBLE

At first, hair doesn't have much of its own shape; it follows the shape of the skull. Add simple dots and dashes to show the sparse growth of hair. To give it a fuzzy texture, outline the skull with small lines instead of using a single, solid line.

JUST GROWING IN

Hair isn't very smooth as it comes in. Lengthen your lines a little and draw more of them to show the increasing thickness of the hair. Add darker patches in the shadowed areas of the head to create depth.

TIGHT CURLS

To draw tight curls, layer spirals on top of each other. For areas with super-short strands, use very curvy short lines.

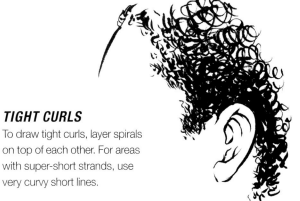

DRAWING BRAIDS

Braids are a realistic and plausible way to style a character's hair in a low-maintenance setting. They don't take long to accomplish, keep the hair out of a character's face and hold up well if subjected to rigorous physical activity.

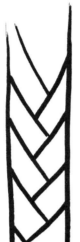
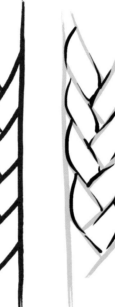
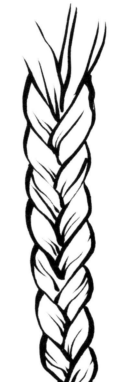

1 START SIMPLE
Start with two simple horizontal lines. Within that column, create two slanted lines that form a slight V, with one of the slants extending lower.

2 REPEAT THE V SHAPE
Repeat the V shape to create a herringbone pattern.

3 ROUND THE EDGES
Take the edges in and round them. The result will look like coiled rope with the sides pressing inward.

4 ADD DETAIL AND CREATE TEXTURE
Add detail by drawing some strands in the braid to create texture.

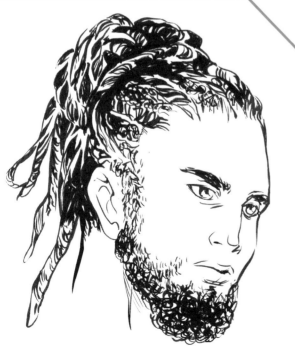

CONTRASTING TEXTURE
Sometimes, it's appropriate to use two different textures for the hair of a single character. Here, the beard is comprised of very tight curls, but on the head those curls have been pulled into dreadlocks.

Clothes

There is no excess here in the wasteland. Every scrap is treasured and used, and clothes are worn until they fall apart. Learning how to draw fabric that's torn and frayed will help set the scene.

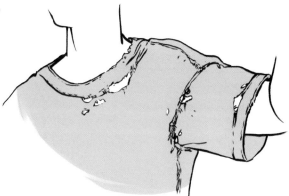

COMING APART AT THE SEAMS
Garments are joined together with seams. As clothes start to wear out, the seams are usually the first areas to go.

Use a curve placed against the seam to show where the fabric will start separating. Then add frayed edges to the torn thread and uneven fabric to the bottom part of the curve. At the corners, where the rip is still attached to the seam, the thread will be visibly stretched out and attempting to hold the two pieces of fabric together.

WEAR AND TEAR
Fabric takes a beating on parts of the garment that get a lot of pull and friction from the body, like the knees or elbows.

THAT RIPPED LOOK
If you're drawing tears that will be seen from a distance, simplify them by creating some uneven lines to represent jagged fabric.

PROGRESSION OF DAMAGE
Practice taking a pair of jeans from brand-new to tattered and dirty. First, identify the areas that will take the brunt of the damage. The most severe tearing will happen at the back edge, tapering off to the front, because the lower part gets dragged through mud, sand and gravel. When you've noted the correct placement, add tears and frayed seams.

HIGH DAMAGE VS. LOW DAMAGE

Some areas of a garment will take more wear than others. Use smoother lines on the sections of fabric that aren't edges, like the curve of the hood and the wrap of the skirt. Then sketch the bottom of the fabric with uneven, broken lines to contrast it with the areas that are just folded.

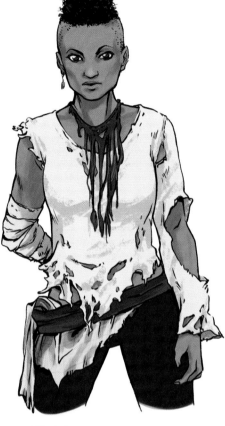

EXTREME TEARING

You don't have to stop at minor damage to your characters' clothing. Here, one of the sleeves has completely torn off, and she's wearing the collar of another shirt as a necklace.

FABRIC WRAPS

Wrapping torn strips of fabric around a body shouldn't be neat and even. This cloth represents the far end of the damage scale—fabric that's so worn it was useless on its own and has been broken down for a new purpose. As such, the strips themselves are uneven, and the wearer probably cares more about coverage than neatness.

FULL COVERAGE

Try drawing someone with wrapped arms or legs. Make sure to keep it messy, and bear in mind that the wraps will bulge a bit on the sides as the fabric strips overlap each other.

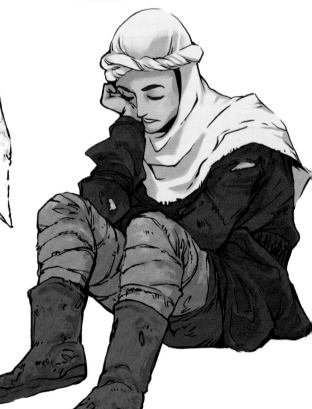

Accessories

In a post-apocalyptic wasteland, accessories have a lot less to do with whether a purse matches a dress and a lot more to do with what can be cobbled together. Keep in mind what's available while you're outfitting your characters, and have fun playing with unexpected scraps from the world we currently know.

Weapons

With no remaining means to manufacture weapons, wasteland dwellers can't rely on anything fresh or new. When the going gets tough, they get creative. Anything that does damage has the potential to be a weapon, and separate objects can be combined with wire, cloth and leather to make them more effective.

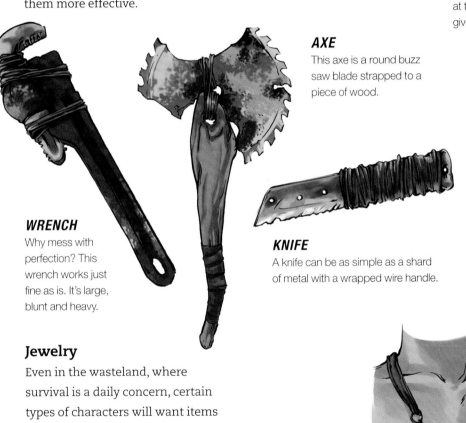

AXE
This axe is a round buzz saw blade strapped to a piece of wood.

MACE
The large nuts and bolts at the head of this mace give it more clout.

PIPE HAMMER
Intersecting seg-ments of pipe make a formidable hammer.

WRENCH
Why mess with perfection? This wrench works just fine as is. It's large, blunt and heavy.

KNIFE
A knife can be as simple as a shard of metal with a wrapped wire handle.

Jewelry

Even in the wasteland, where survival is a daily concern, certain types of characters will want items created for the sake of decoration. But here, too, the standards have changed. After all, who can make perfectly cut precious gemstones without the proper tools? Instead, experiment with other objects: bottle caps, bobbins, buttons and bits of chain. For something shiny and eye-catching, opt for scraps of technology like flash drives or broken watch faces.

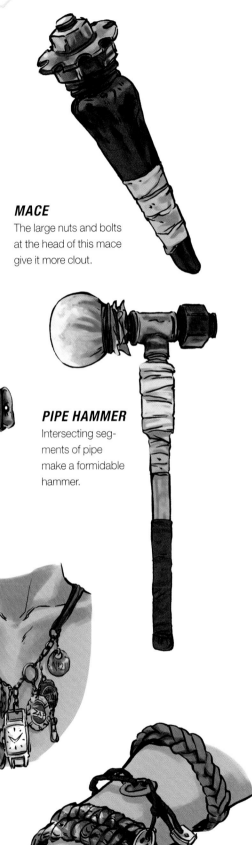

Look Wasted

While you're designing your objects and accessories, make sure they fit your setting. Remember, the apocalypse has come and gone, and there have been a few hard years in between. Make a conscious effort to ensure that things look "wasted."

AGE IT UP

Water bottles are generally sleek and smooth; they're symmetrical and have straight lines. In this case, add some dents and damage to make them at home in a broken, gritty setting.

A NEW WAY TO RECYCLE

Items that are discarded in our contemporary world are harder to come by in the wasteland. Water bottles and cans can be kept on-hand to eat or drink from.

 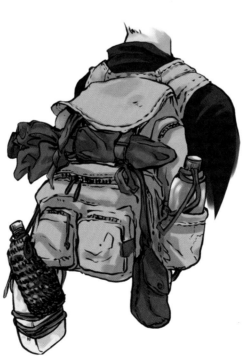 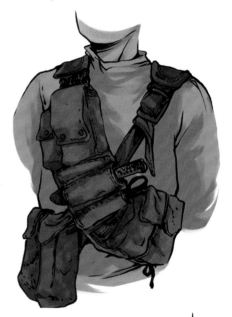

TAKE IT WITH YOU

Nomadic people have to carry their belongings with them, so storage and carrying packs are a must. They can range from the simple to the stylish, but should be functional above all else.

Desert Dwellers

If your particular wasteland is full of sun, sand and not a lot else, you'll want to give some thought to how people survive in a desert before you design your characters. Dress them appropriate to harsh conditions, and take into account the punishing weather.

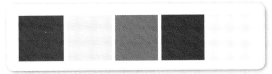

THE DESERT PALETTE

Take your colors from the setting itself. Use washed-out earth hues with a splash or two of color to set the tone, and remember to keep your palette in mind as you work.

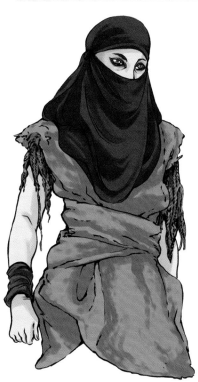

VARIETY: THE SPICE OF ART

With a bland desert palette, you can't always rely on color for visual interest. Try adding some variety by using multiple textures. Here, the inked lines of the veil are flowing, making it look smoother and lighter than the wrapped tunic. The torn knitwear at her arms makes a third distinct texture. When you add color, use different strokes to help distinguish between them.

SET IT IN INK

Different inking techniques are an important base for establishing a variety of textures. Try drawing the same garment with several different inking styles to see how the look changes.

DOTS AND DASHES

Something as simple as groupings of dots can create texture and depth. Combine a greater number of dots to show shadows, or use patterns on fabric to show some visual and textural difference.

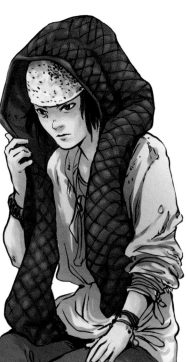

GO WITH THE FLOW

The texture of this fabric isn't a straight checkerboard. It has to follow the flow and curves of the fabric to make it look three-dimensional.

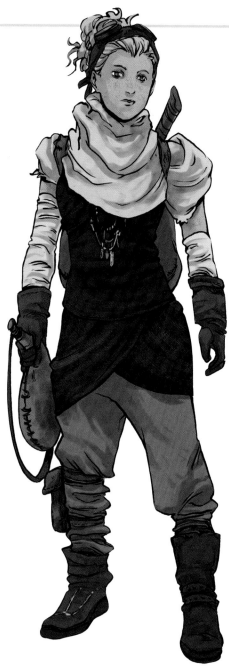

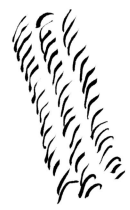

THE POWER OF INK

Remember, changing your ink lines goes a long way toward suggesting different textures. If your character is wearing fur or leather, your inking style can suggest that.

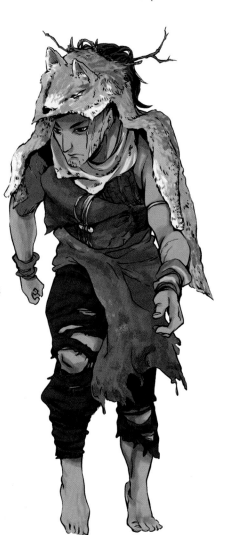

MIX AND MATCH

In a desert wasteland, the inhabitants can't afford to be choosy. If your characters have scavenged for their goods, expect mismatched outfit pieces like overlapping shirts or one-off boots. Texture helps to make the differences between them stand out.

SKINS AND HIDES

Some wasteland dwellers don't scavenge; they hunt. If your character prefers clothes they can make for themselves, you can add animal hide to your textural arsenal. Fur offers a huge variety: choose between long or short, straight or curly, and thick or sparse.

THE SCAVENGER

The pre-disaster world is long gone, and most people have left it behind with hardly a backward glance. Not the Scavenger; he makes it his living. Out in the desert, there are still scraps of technology and furniture, pieces of a long-forgotten way of life. He's out in the heat every day from dawn to sunset, digging deep to find what the sand keeps hidden. When he's cleaned it up and brought it into one of the shantytowns along his trade route, he always finds enough of a barter to make it worth his while.

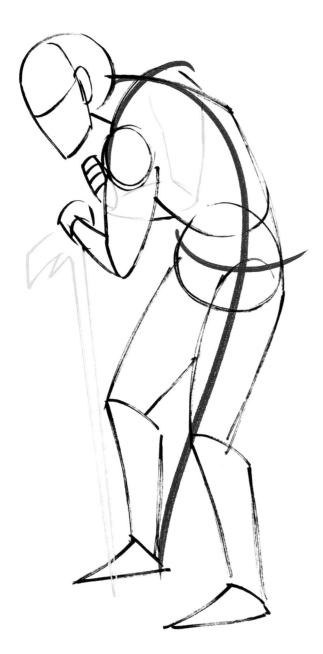

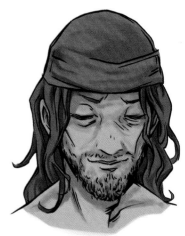

1 STRIKE A POSE

The Scavenger carries the weight of the world—or at least the weight of his stuff. All of his possessions are on his back, so he's extremely stooped over. Add a curve to the spine; it would probably curve even lower if he didn't have a cane.

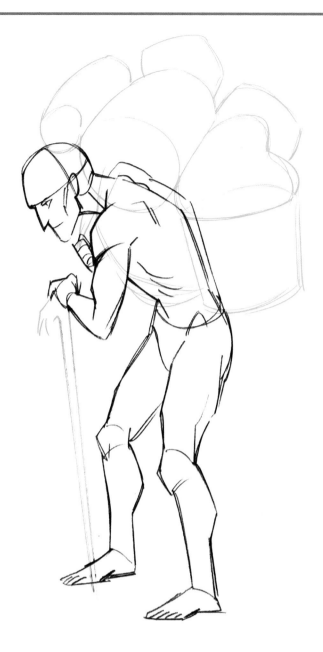

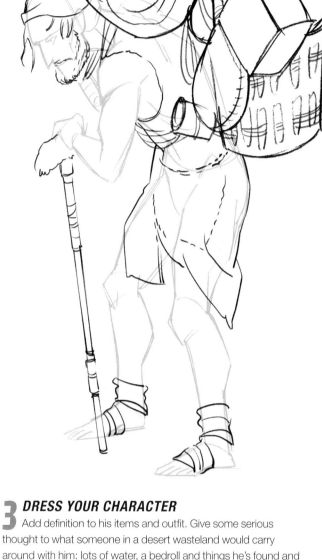

2 FILL IT IN

Start paying attention to anatomical details. The Scavenger is thin, but wiry and strong, so add lots of sharp angles and use barely any curves to show body fat. He has deep-set eyes and defined cheekbones in a thin face, so sketch that in now. Start adding the general shapes of what he's carrying—just the size of things at first, without going into too much detail.

3 DRESS YOUR CHARACTER

Add definition to his items and outfit. Give some serious thought to what someone in a desert wasteland would carry around with him: lots of water, a bedroll and things he's found and saved for trading. His clothing is simple, with fabric stitched sloppily together, and his shoes are just leather soles wrapped around his feet with fabric.

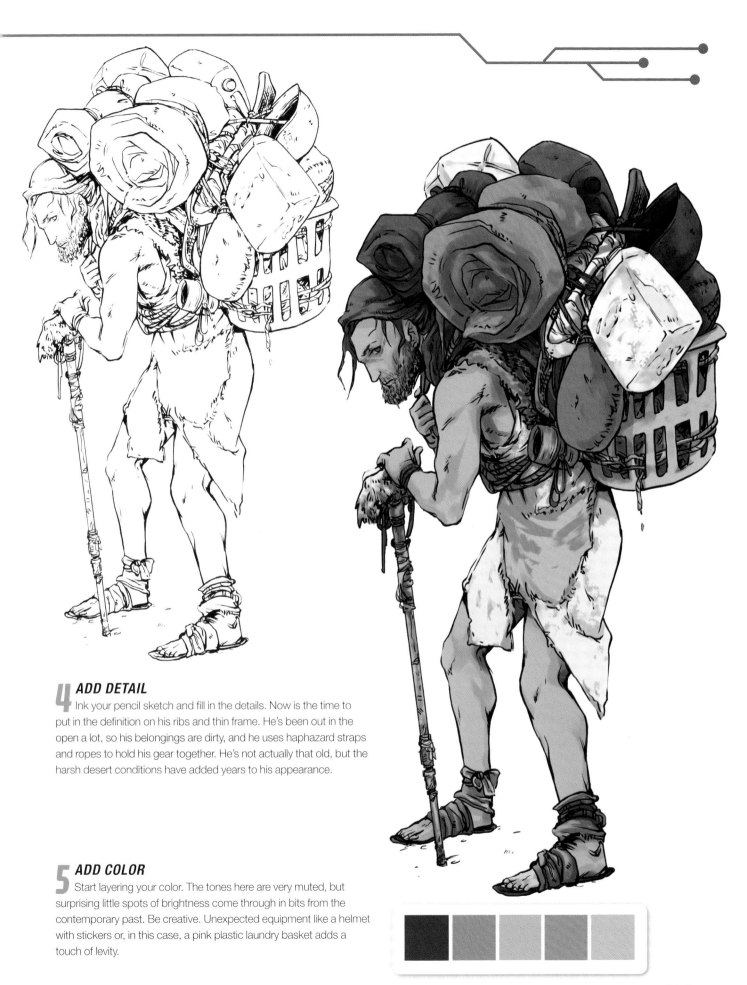

4 ADD DETAIL

Ink your pencil sketch and fill in the details. Now is the time to put in the definition on his ribs and thin frame. He's been out in the open a lot, so his belongings are dirty, and he uses haphazard straps and ropes to hold his gear together. He's not actually that old, but the harsh desert conditions have added years to his appearance.

5 ADD COLOR

Start layering your color. The tones here are very muted, but surprising little spots of brightness come through in bits from the contemporary past. Be creative. Unexpected equipment like a helmet with stickers or, in this case, a pink plastic laundry basket adds a touch of levity.

THE WARRIOR

The Warrior had a name once. She had a family, too. But that was a long time ago, and those years are dead and gone. What's left behind is a grim shell of a person, with all the softness stripped away. She's been on her own for ages beneath the punishing desert sun and she knows how the game is played. It's kill or be killed out in the vast expanses where nothing civilized dares to tread—and she's killed her fair share.

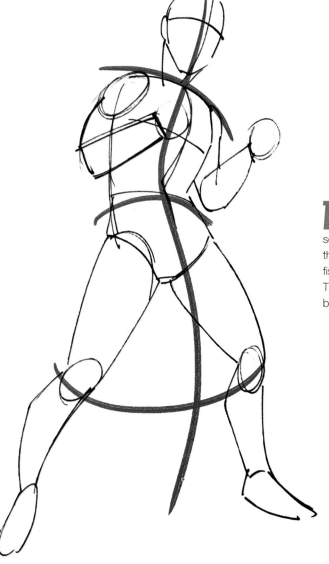

1 STRIKE A POSE

Start with the pose—in this case, someone getting ready for a fight. Draw the feet planted on the ground and the fists up to defend the face from blows. The back curves slightly, and the torso is bent inward.

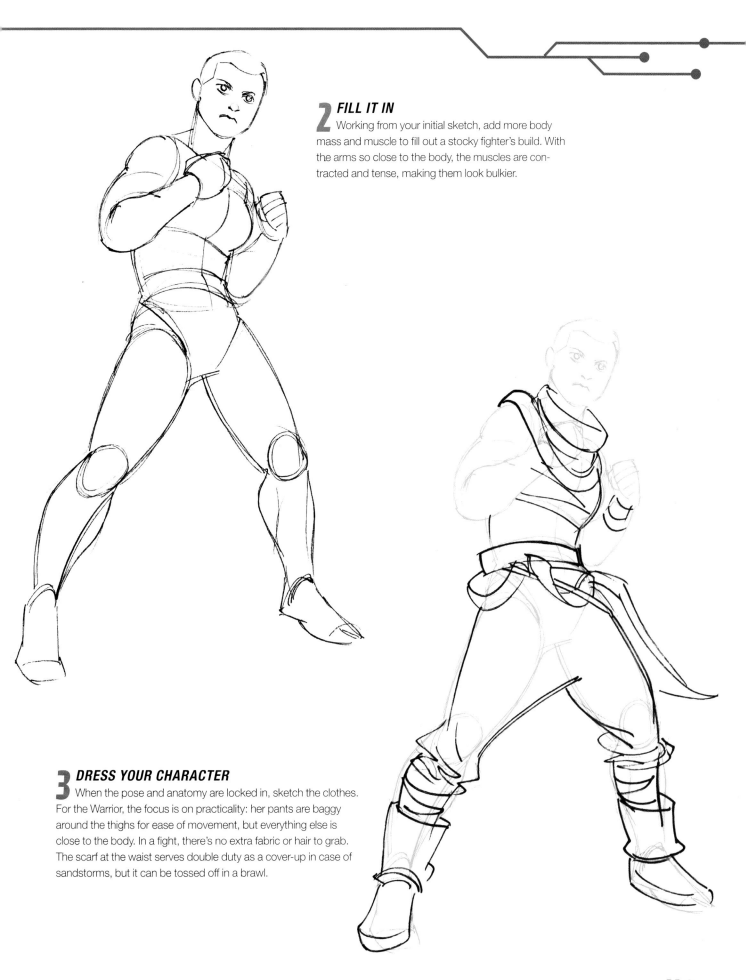

2 FILL IT IN

Working from your initial sketch, add more body mass and muscle to fill out a stocky fighter's build. With the arms so close to the body, the muscles are contracted and tense, making them look bulkier.

3 DRESS YOUR CHARACTER

When the pose and anatomy are locked in, sketch the clothes. For the Warrior, the focus is on practicality: her pants are baggy around the thighs for ease of movement, but everything else is close to the body. In a fight, there's no extra fabric or hair to grab. The scarf at the waist serves double duty as a cover-up in case of sandstorms, but it can be tossed off in a brawl.

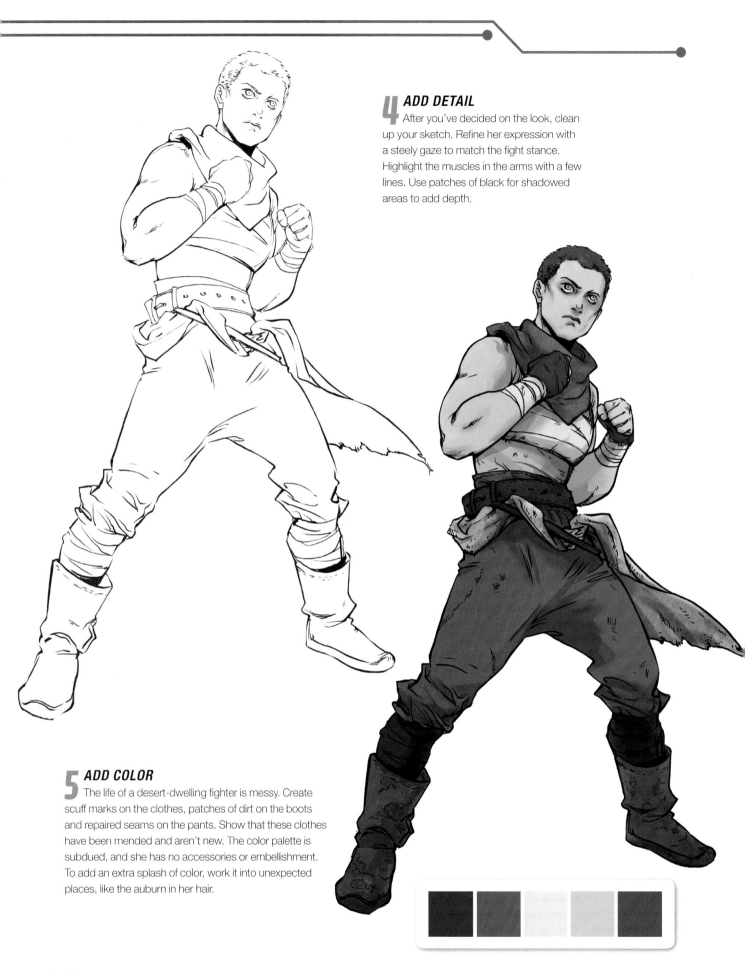

4 ADD DETAIL

After you've decided on the look, clean up your sketch. Refine her expression with a steely gaze to match the fight stance. Highlight the muscles in the arms with a few lines. Use patches of black for shadowed areas to add depth.

5 ADD COLOR

The life of a desert-dwelling fighter is messy. Create scuff marks on the clothes, patches of dirt on the boots and repaired seams on the pants. Show that these clothes have been mended and aren't new. The color palette is subdued, and she has no accessories or embellishment. To add an extra splash of color, work it into unexpected places, like the auburn in her hair.

City Dwellers

Even in the wasteland, there are small bastions of civilization. Here, the environment is more stable, so characters have freedom to experiment in situations that aren't life-or-death. Take the opportunity to play around with fashion and styles. City dwellers are able to create and dye fabric, and the old world has been gone a long time, so the sky's the limit in terms of what's popular.

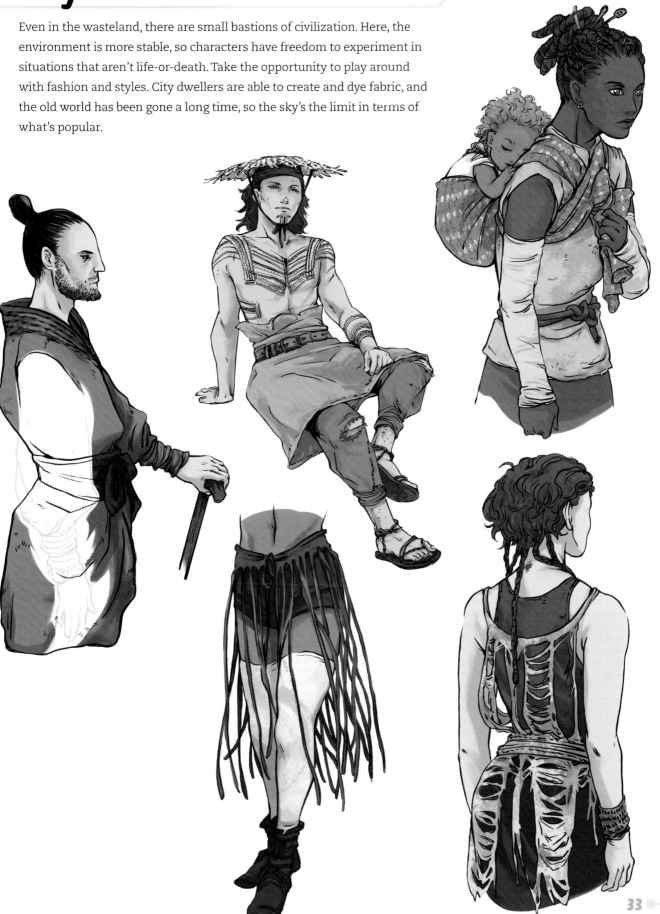

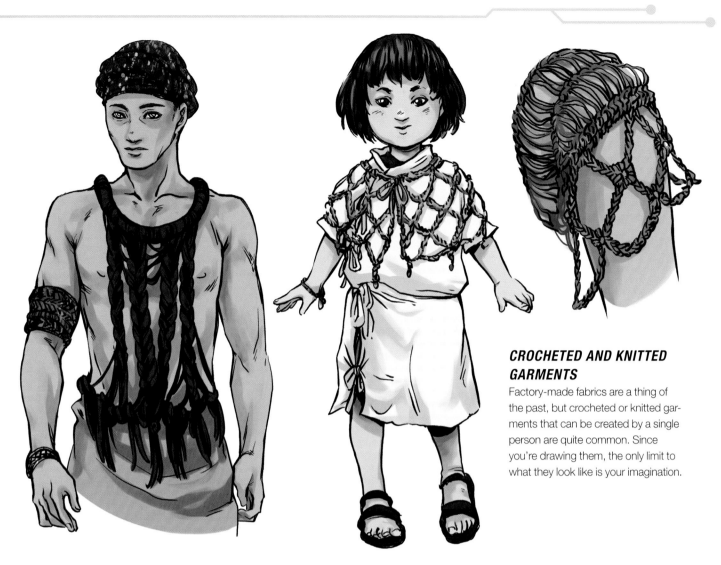

CROCHETED AND KNITTED GARMENTS

Factory-made fabrics are a thing of the past, but crocheted or knitted garments that can be created by a single person are quite common. Since you're drawing them, the only limit to what they look like is your imagination.

TIGHT PATTERN

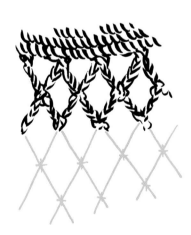

OPEN PATTERN

You can see through the gaps in the diamonds in this more open pattern.

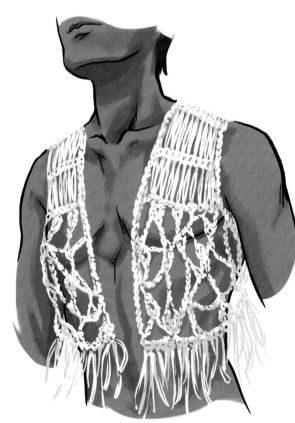

THE BARTENDER

In a world gone to pieces, the Bartender forged a place of her own. She used to be a mercenary, but that lost her an arm and a young girl's dreams. Now she runs a water bar where parched travelers can come in out of the heat to quench their thirst. Tough and no-nonsense, the Bartender could write the guidebook on dealing with some of the scum that washes in out of the desert. She'll take their trade goods in barter, but her rules are hard and fast: leave your weapons at the door and cause no trouble. Anyone who breaks those rules is apt to find out that her prosthesis definitely favors function over form.

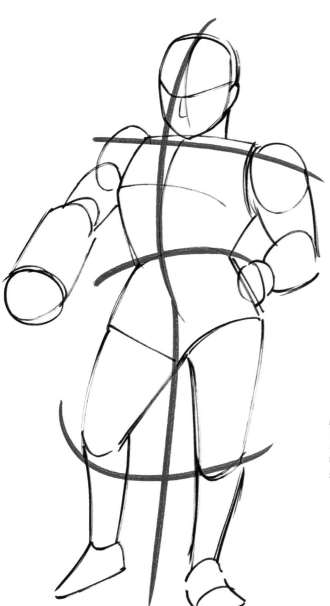

1 STRIKE A POSE

Since the Bartender has a strong personality, give her a strong, no-time-for-your-BS stance. She's short and stocky—and she's standing her ground—so plant her legs firmly.

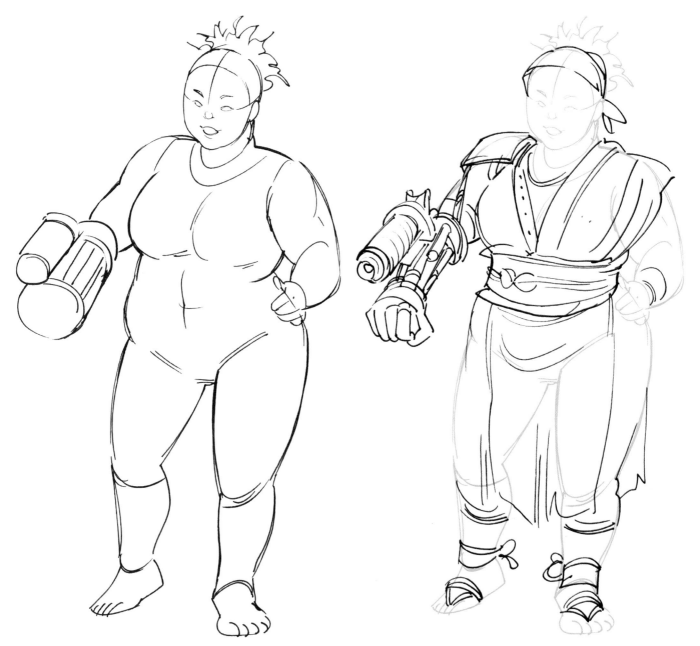

2 FILL IT IN

Complete the initial outline, then add her extra weight. Flesh out the body, keeping in mind that extra bulk goes out but also down due to gravity. At this point, start adding in hints as to what her face and hair will look like. For the prosthetic arm, lay in a simple cylinder for now.

3 DRESS YOUR CHARACTER

Start sketching out more detail on the prosthetic arm using the original cylinder sketch as a guide. It will serve double duty as a gun, so keep that in mind as you work in smaller cylinders in the middle to act as the "bone" and twine wires and cables around it. Because of the weight of the arm, she needs a weight belt to help her support it.

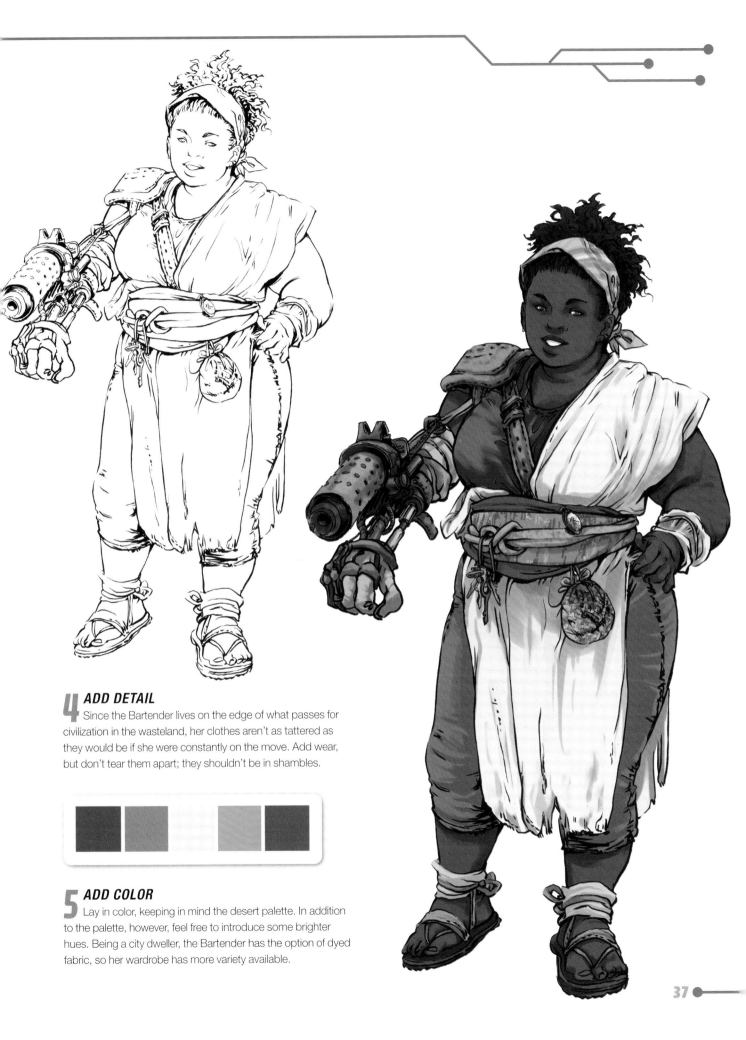

4 ADD DETAIL

Since the Bartender lives on the edge of what passes for civilization in the wasteland, her clothes aren't as tattered as they would be if she were constantly on the move. Add wear, but don't tear them apart; they shouldn't be in shambles.

5 ADD COLOR

Lay in color, keeping in mind the desert palette. In addition to the palette, however, feel free to introduce some brighter hues. Being a city dweller, the Bartender has the option of dyed fabric, so her wardrobe has more variety available.

SETTING THE SCENE

You've designed your characters. You've outfitted them for a desert waste-land. Now it's time to bring their world to life by creating a detailed, believable backdrop for daily life.

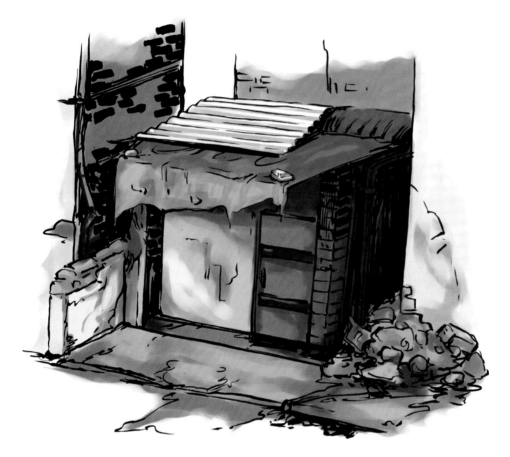

1 ESTABLISH A LAYOUT

Before you do anything else, start by creating a floor plan overview. This particular setting is a tiny, one-bedroom house, so think about what would be there. Make sure you cover the necessities: a bed, a stove for heating and cooking, a small table and a shelf for storage. (The outhouses are outside.)

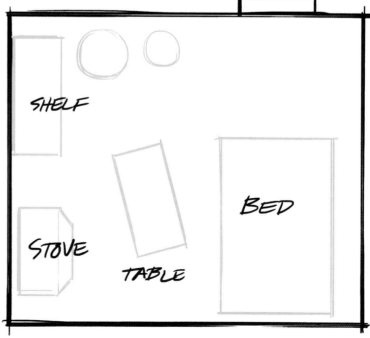

SHELF

BED

STOVE

TABLE

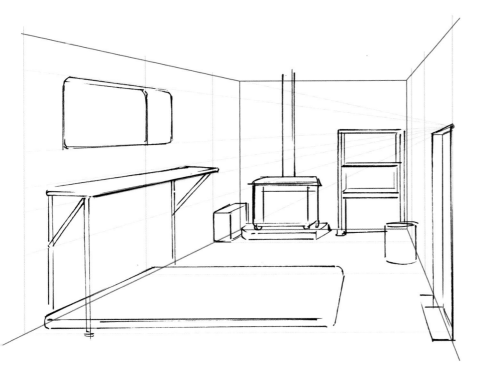

2 CHOOSE AN ANGLE AND PUT IT IN PERSPECTIVE

Play around with angles until you determine how you want to frame the scene. An easy way to compare the possibilities is to make lots of quick thumbnail sketches from various points of view. Since this example is only one room, set it up like a cube. Place the furniture where it went in your overview sketch, but change the angle accordingly. This is the angle we'll use for this demonstration. It shows multiple elements of the room and offers a clear view of the doorway and the window.

Now It's time to start figuring out perspective. If you elongate the left wall, it keeps the scene from being too symmetrical and shows more of the window, shelf and bed. The vanishing point is the red dot at the corner of the doorway.

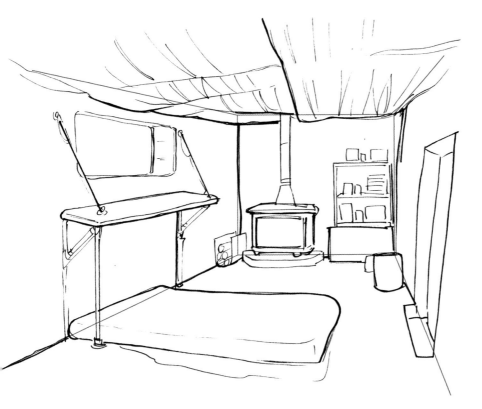

3 MATCH THE SETTING

Start adding more content to the interior. To make it fit into the setting, get rid of most of the straight lines. The ceiling is a bit wavy—a combination of woven plastic and corrugated tin. Even the wall on the right and the doorway are slanted.

4 FILL IT IN

Have some fun thinking about the kinds of things that would fit into this type of home. Take into consideration what is needed to live, but also what's comfortable for the family who spends their lives here. Edible plants crammed right next to the window take advantage of the available light. A stove serves for both warmth and food prep. Shelves provide storage, a small table doubles as a work surface and dining area, and the rugs on the floor and the collection of pillows and blankets on the bed add a lived-in touch.

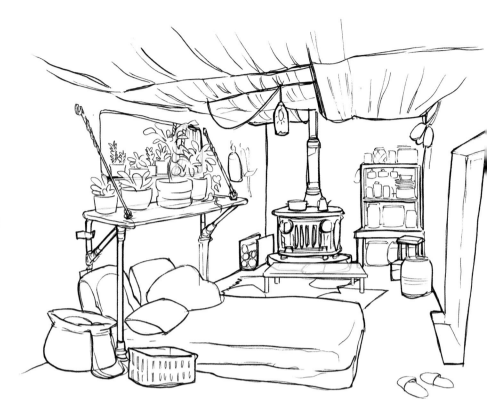

5 ADD DETAILS

Now's the time to really sell your setting. Add in little hints of the outside world to tie this home together with what you've already established. The grill of the stove started life as a jeep grill; it's been scavenged from an unusable vehicle. The planters are made of rubber tires, and the window shelf is held up with cobbled pieces of pipe. Everything is showing wear; the walls, furniture and household goods are all a little dingy and well-used.

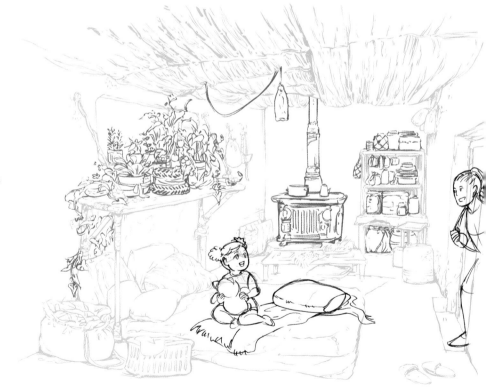

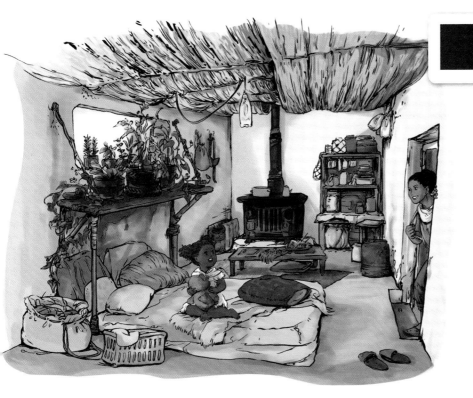

DAYTIME PALETTE

In the morning, try coloring the scene with natural light, yellows and oranges. Provide a warm tint to the beiges and grays within the house; even the green on the plants is tinted yellow. Add lively expressions to the characters to match the colors and complete the picture of a vibrant, happy scene.

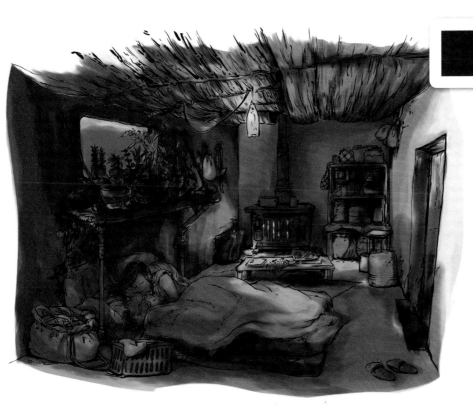

NIGHTTIME PALETTE

Try leaving the angle and room the same, but switching to a nighttime palette. There is some light coming in through the window, but the blue shadows don't tint the interior. The plants have dulled to a blue-green shade, and the embers in the stove cast a faint yellow-orange glow.

6 EXPERIMENT WITH DIFFERENT COLOR PALETTES
Using a different color palette can give the same scene an entirely different feel.

Urban Dystopia

The future is here—and with it came a government that rules with an iron fist, a huge class divide and a lot of very unhappy people. In the urban dystopia, it's just second nature that the population is divided into two starkly different groups: the Haves and the Have-nots. The Haves live a charmed life in the relative peace and plenty of the city center, spending their days on frivolous pursuits of pleasure. The Have-nots are pushed to the outskirts and forced to eke out a meager existence on the leftovers. Sounds like a recipe for revolution.

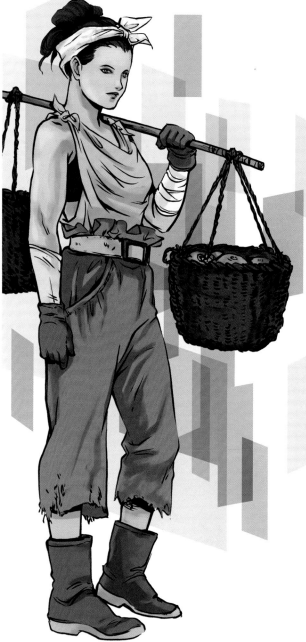

Hair

In the glamorous city center, the Haves show off hairstyles that put form over function. Big, extravagant shapes and complicated up-dos are all the rage, but behind every over-the-top style is a basis in anatomy. Before you start drawing, make sure you know how the hair sits on the skull.

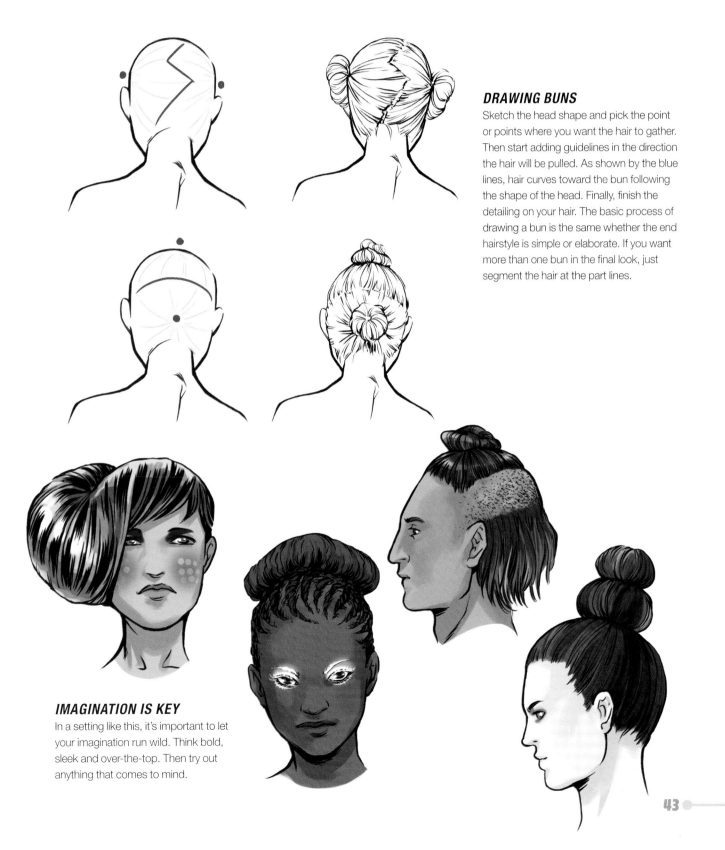

DRAWING BUNS
Sketch the head shape and pick the point or points where you want the hair to gather. Then start adding guidelines in the direction the hair will be pulled. As shown by the blue lines, hair curves toward the bun following the shape of the head. Finally, finish the detailing on your hair. The basic process of drawing a bun is the same whether the end hairstyle is simple or elaborate. If you want more than one bun in the final look, just segment the hair at the part lines.

IMAGINATION IS KEY
In a setting like this, it's important to let your imagination run wild. Think bold, sleek and over-the-top. Then try out anything that comes to mind.

Trendsetters

The city center is home to the privileged few, but among those few, the celebrities are revered as fashion gurus and trendsetters. They want to be seen—and everyone else wants to see them—so they adore styles that catch the eye. When you design clothing for this set, reach for the absolutely ostentatious. Take your inspiration from anywhere and everywhere: retro-future sci-fi, historical dress, current couture fashion or anything else that you enjoy.

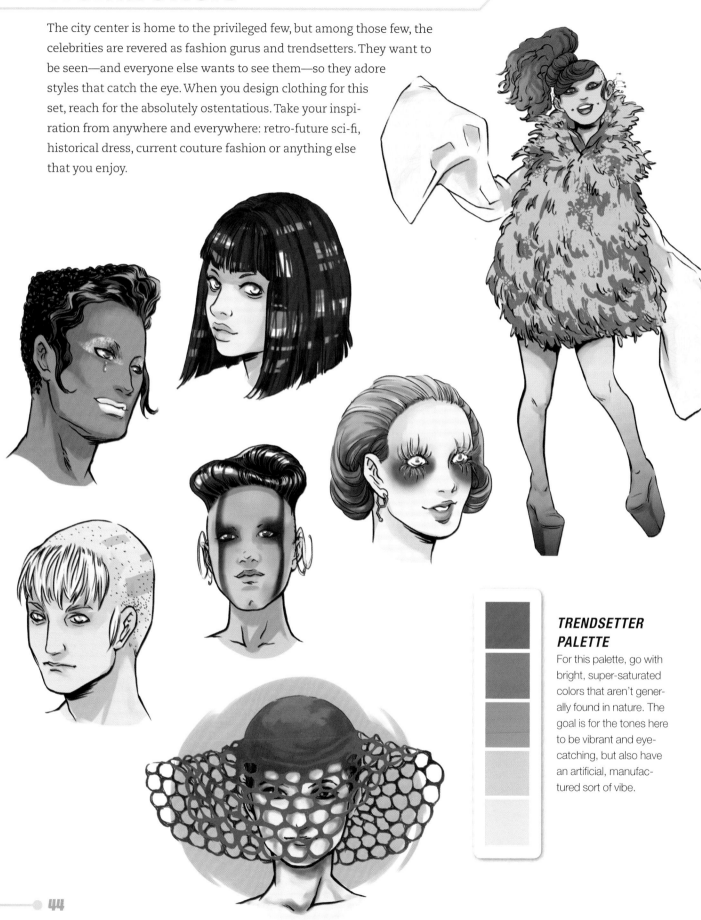

TRENDSETTER PALETTE
For this palette, go with bright, super-saturated colors that aren't generally found in nature. The goal is for the tones here to be vibrant and eye-catching, but also have an artificial, manufactured sort of vibe.

TRANSPARENT FABRIC

Among the glitz and glam, there's room for fabrics that won't appear in settings that are based in practicality. Flimsy, transparent materials are the perfect illustration of style over substance.

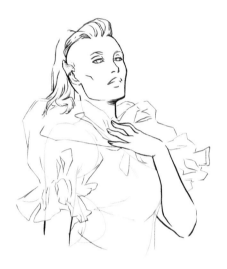
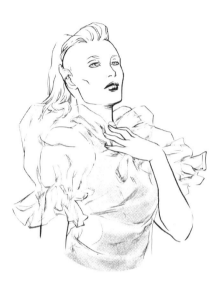

1 OUTLINE YOUR FABRIC

Outline your fabric to show where it will fall in relation to the body. The red lines here show the fabric, and the blue lines show what parts of the body lie beneath it. In this example, the material is stiff and holds its own shape, so it isn't clinging to her form.

2 BLACK AND WHITE

In a pen-and-ink version, use a thinner line or a different pen with a finer point for the outline of the shirt. Also use a thinner line for the parts of the body visible through the shirt. In contrast, the ink lines on the rest of the body and face will be thicker. The difference in line width makes it appear as though the viewer is looking through sheer fabric.

3 CHANGE THE OUTLINE

In a colored version, change the outline of the transparent material to white instead of black. This helps to lighten the cloth compared to the rest of the drawing, which still has the heavier black outline.

4 ADD WHITE

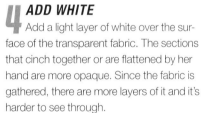

Add a light layer of white over the surface of the transparent fabric. The sections that cinch together or are flattened by her hand are more opaque. Since the fabric is gathered, there are more layers of it and it's harder to see through.

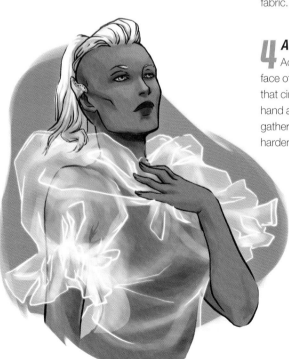

EXPERIMENT!

Transparent fabric can be used in almost any kind of garment regular fabric can. Try out a few designs and practice coloring them to get the feel for it.

Shapely Figures

For unusual, futuristic-looking fashion, try playing around with geometric shapes. A lot of clothes follow the line of the body, but if the fabric is stiff or contains wiring to help it hold its shape, it can hold almost any form the designer desires.

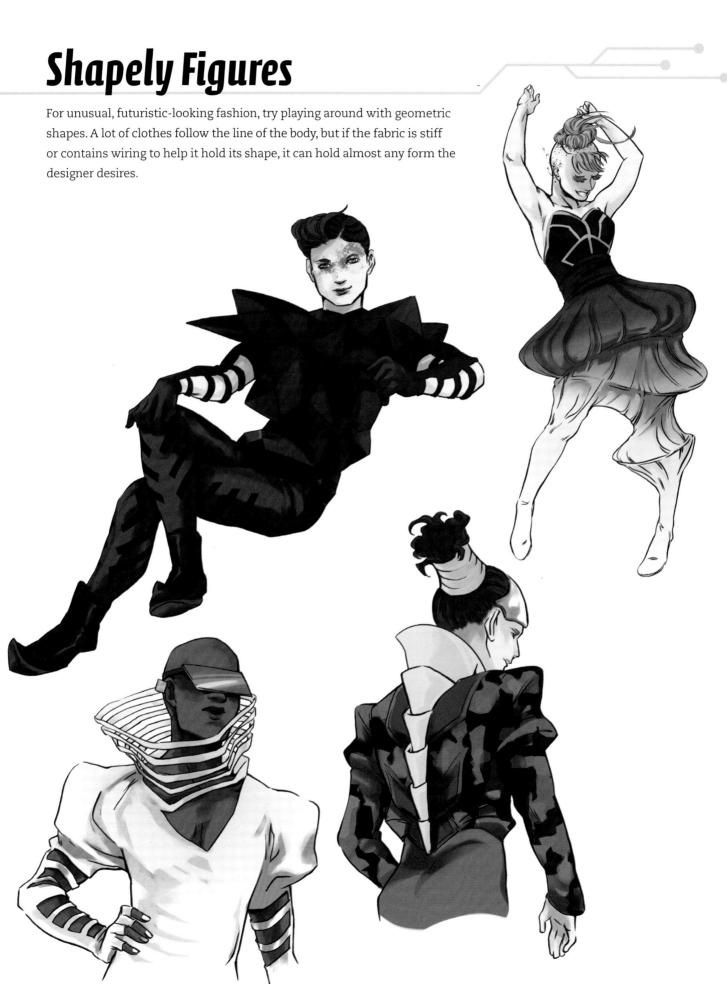

Light It Up

Who needs glow sticks with clothes like these? If your characters' garments are self-lighting, create a glow effect with a soft gradient and a brighter, nearly white area in the middle. Make the outline the darkest shade of your desired color.

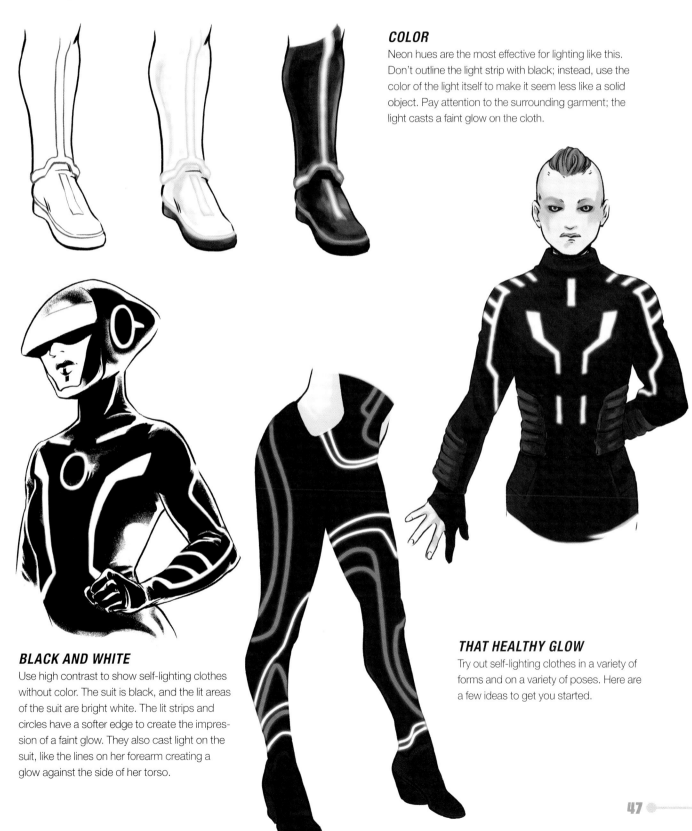

COLOR

Neon hues are the most effective for lighting like this. Don't outline the light strip with black; instead, use the color of the light itself to make it seem less like a solid object. Pay attention to the surrounding garment; the light casts a faint glow on the cloth.

BLACK AND WHITE

Use high contrast to show self-lighting clothes without color. The suit is black, and the lit areas of the suit are bright white. The lit strips and circles have a softer edge to create the impression of a faint glow. They also cast light on the suit, like the lines on her forearm creating a glow against the side of her torso.

THAT HEALTHY GLOW

Try out self-lighting clothes in a variety of forms and on a variety of poses. Here are a few ideas to get you started.

THE HOST

The Host has never known life outside the grand and glittering spectacle that makes up the city center—and he's never wanted to. As the face of one of the city's most popular television programs, the Host has thousands of adoring fans, and he wouldn't have it any other way. Affable, self-centered and flamboyant, he's in love with his life and doesn't understand why anyone could think the world needs changing. Underneath all the glitz and glam, there's a decent person, but he's so insulated from the hardships experienced by the less-fortunate that he's blithely unaware they even exist.

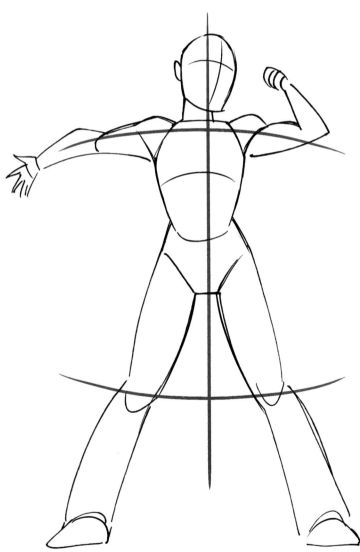

1 STRIKE A POSE

Try out poses until you get one that suits the character's personality. This one fits the Host quite well: he's confident with his chest puffed out and arms gesturing widely. It's missing a little something, though—namely, drama.

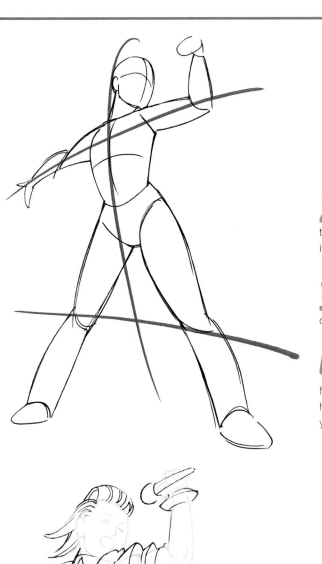

2 CHOOSE AN ANGLE
Turn the pose sideways and add some foreshortening to make things more dynamic. Even though he's standing in one spot, now it feels like his pose has some movement to it.

3 ADD DETAIL
Start sketching in more details in the face, anatomy and clothes.

4 INK IT UP
When you're happy with how the sketch looks, it's time for your final pencils or inks. If you know you'll be coloring a piece, you don't have to add all of the clothing patterns right now. Holding off until you color will make your job easier.

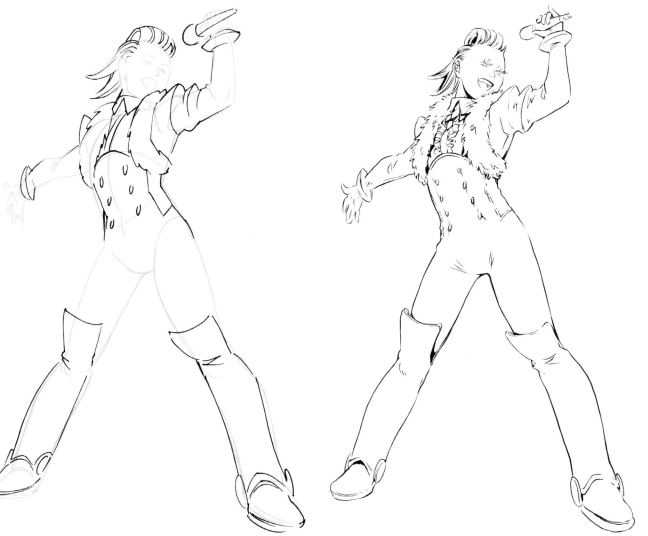

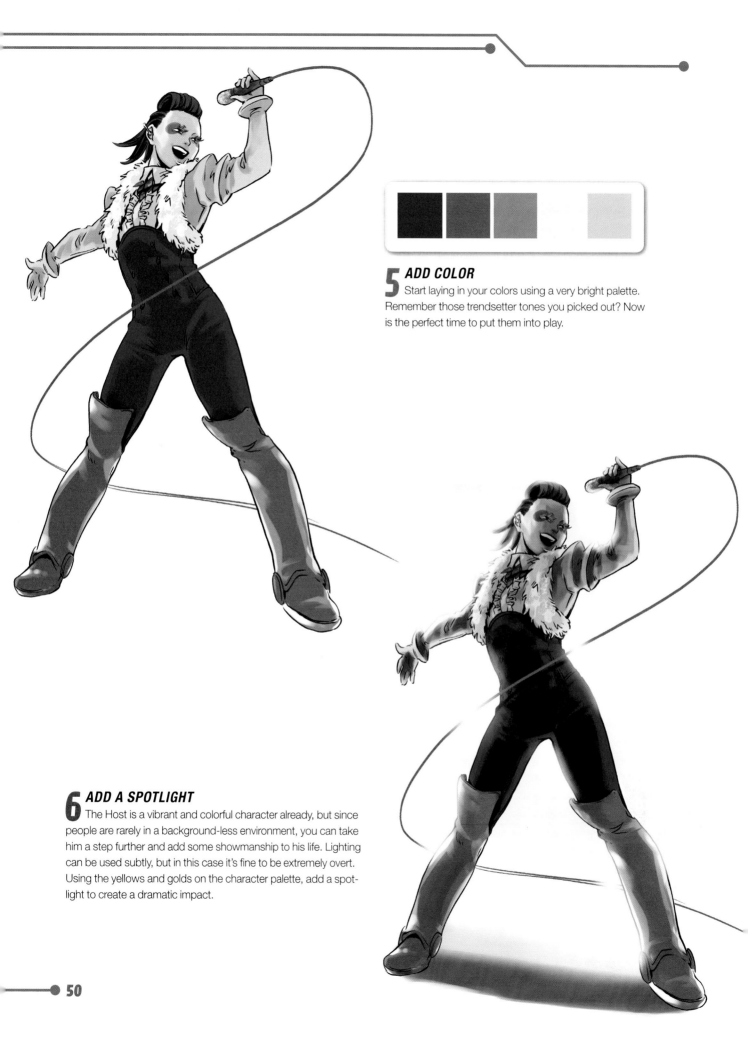

5 ADD COLOR

Start laying in your colors using a very bright palette. Remember those trendsetter tones you picked out? Now is the perfect time to put them into play.

6 ADD A SPOTLIGHT

The Host is a vibrant and colorful character already, but since people are rarely in a background-less environment, you can take him a step further and add some showmanship to his life. Lighting can be used subtly, but in this case it's fine to be extremely overt. Using the yellows and golds on the character palette, add a spotlight to create a dramatic impact.

The Upper Crust

The trendsetters aren't the only ones who live the high life in the city center. Business men and women and various other types of professionals fit right into this world of ambition and luxury. Their clothes aren't as outrageous as the trendsetters', but the designs are still outlandish compared to our everyday wear. Dress them for the office, not a party—complete with that sleek, tailored look. This set cares about appearances, so you can bet their kids are every bit as fashionable as they are.

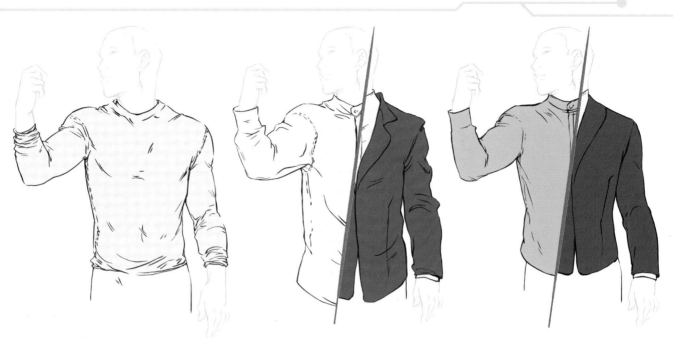

FORM FITTING

A fitted shirt of clingy fabric hugs the body, but not the same way that tailored clothes do. For something more formal, start with a suit as a premise and translate it to your setting. It makes the character look more put-together and calls to mind a business environment.

OFF THE RACK

Before tailoring a suit to your character, try the other extreme. On the left, the dress shirt is too loose, hangs off the body and creates a lot of wrinkles. The suit on the right has sleeves that are too long, the top of the lapels don't rest flat on the collar, and the shoulder seam dips inward.

A PERFECT FIT

Now try tailoring the suit. The end result is a properly-fitted outfit and a character that appears like he has money to spend on a nice wardrobe. Note the differences in the garment itself; it looks much cleaner, and the seams and lines of the clothing fit better.

DRESS FOR SUCCESS

Take the concept of a contemporary suit and use it to create formal business attire for any setting. Just decide on a style and look for your world, then apply that aesthetic to a more conservative manner of dress. For more tips on drawing modern, real-world suits and formal wear, check out *Shojo Fashion Manga Art School: Year 2.*

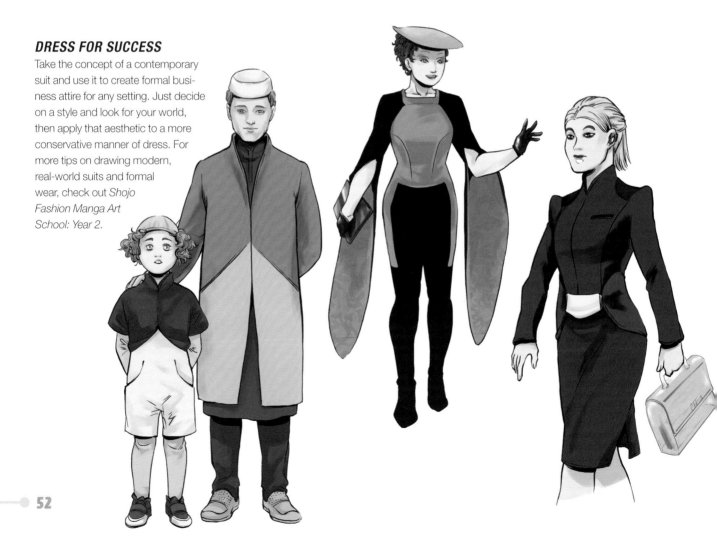

The Ruling Class

Urban dystopias are not democracies; someone somewhere is calling the shots, and that's the ruling class. As with the upper crust, dress them in expensive, well-tailored clothes. Appearances matter, but they aren't aiming for shock value—the final design should be imposing in both look and palette, but not outlandish. If the rulers don't want the unwashed masses to know who's pulling the strings, masks and veils serve to hide their faces.

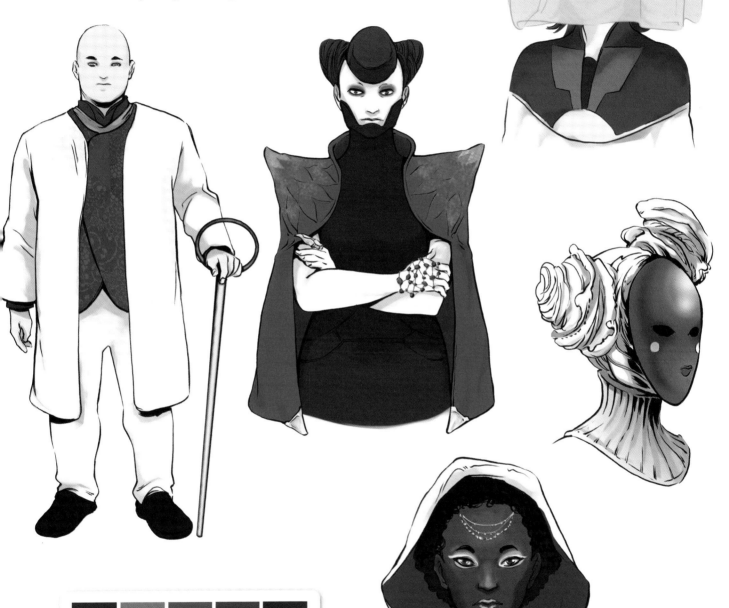

TYRANNICAL PALETTE
The palette for the ruling class employs a lot of deep, cool colors. It's elegant and understated, and it includes the traditional colors of royalty.

Around the World

Cultures from around the world have distinct styles for formal clothes and traditional outfits, and your characters might come from a variety of backgrounds. As the world adapts to the future, fashion in different locations may evolve in different ways, or your characters may opt to take aspects of their personal family history and adjust it to the aesthetic of the city center. If it works for your characters or the location of your setting, consider using different historical dress for your base style before adding some sci-fi flair.

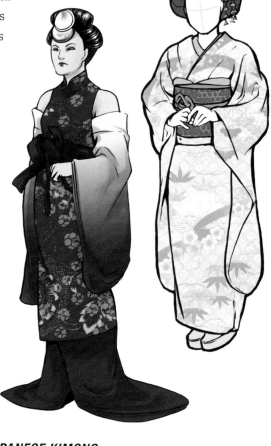

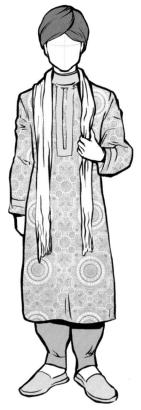

JAPANESE KIMONO

Start by drawing a traditional Japanese kimono. Then replace the hair ornaments with simple geometric shapes. Change the style of the kimono itself to look more minimal and contemporary, and add a central layer (a little like an evening dress) to make the body look sleeker.

INDIAN SHERWANI

Begin with a sketch of an Indian sherwani, taking inspiration from historical Indian royal garb. To add a sci-fi twist, adorn the turban with a sleek metal shape instead of something more traditional. Adjusting textures will give this garment a different look: the top is styled after a leather jacket, and his boots have an iridescent sheen.

TRADITIONAL MEETS FUTURISTIC

Experiment with fashion from around the world. Sci-fi aesthetics don't have to stem from only business suits and lab coats. If your setting is a future Earth, you might want to consider fashion from the country where your story is set to give your characters a unique look.

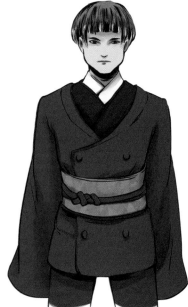

THE SCIENTIST

Someone has to keep the city center running, and it's certainly not the media darlings and fast-talking politicians. It's the Scientist and those like her: the intelligent, focused citizens who do the research that ensures the city is always on the cutting edge of technology. For the Scientist, work is her life. She lives for pushing the envelope and the fascination of seeing what new possibilities her own advances will unlock. Some may call her dispassionate or even cold, but those people just don't understand where her true dedication lies: the laboratory.

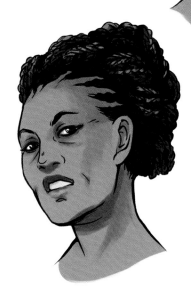

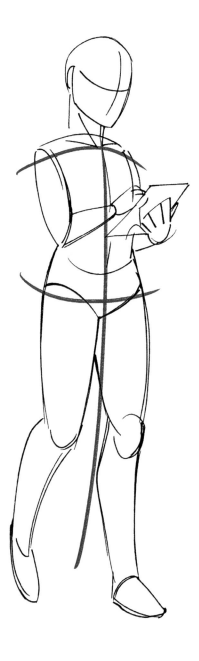

1 STRIKE A POSE

Select a pose that suits your character. For the Scientist, give her something that's simple and straightforward; she isn't posing or putting on a show. Even though she's on her way to an important meeting, her head is down looking at a tablet. Little gestures like this show that she hates being torn away from her work, even for a little while.

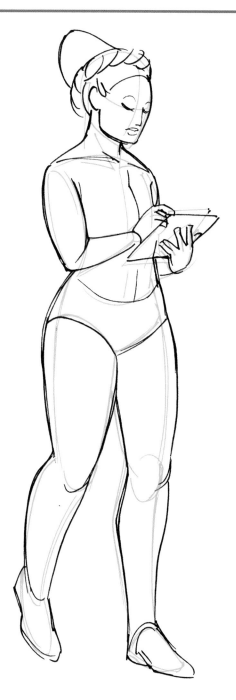

2 FILL IT IN

Start filling out her anatomy and adding more detail. At this point, you'll want to decide her hairstyle—something orderly and out-of-the-way.

3 DRESS YOUR CHARACTER

To match her priorities, her clothing is simple—heavily based on the aesthetic of a contemporary lab coat. Her clothes are comprised of clean lines. She makes sure that there's nothing loose and no buttons or zippers to get caught while she's working. Her shoes are simple, functional and comfortable.

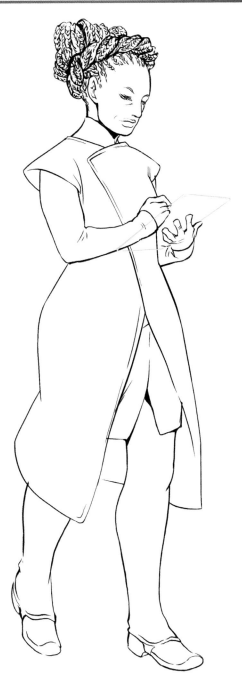

4 ADD DETAIL

The entire outfit is very simple, so at this point, feel free to put in some smaller details. Adding lots of little braids to her hairstyle helps to draw in the viewer's gaze and adds a point of interest.

5 ADD COLOR AND CONTRAST

Like her outfit, the palette here is very simple. Her lab coat is white, and so is the layer underneath. She doesn't care about current fashion; her life is her job, so she's happy with her uniform as is and hasn't added any unnecessary frills.

Now, give the white of her outfit something to stand out against. Add a darkened background to make the tones of her clothes and skin show up more clearly. At this point, change the outline of her outfit from black to white to make it appear cleaner and brighter.

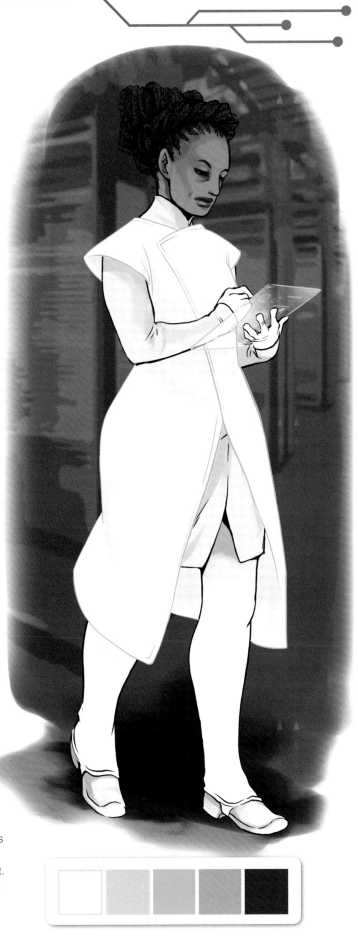

Enforcers

Someone has to make sure the laws of the ruling class are followed. With years of physical conditioning and training in the use of high-tech weaponry, these men and women bring military efficiency and a brutal take-no-prisoners type of law enforcement to the table. They get the job done and will take down anyone who happens to be standing in the way.

ENFORCER PALETTE

This color palette is monochromatic by design—cold and stark. When the enforcers are in uniform, their armor is designed to make them seem inhuman and intimidating.

HELMETS

When designing an enforcer helmet, keep in mind that the masks would not be personalized because the enforcers wear a standardized uniform. Also, you shouldn't be able to see their eyes. The helmet makes the enforcer behind it anonymous, creating a legion of soldiers that seem impersonal and emotionless.

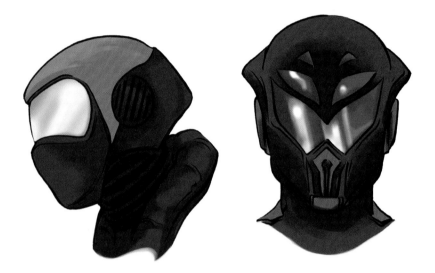

UNIFORMS AND BODY ARMOR

Body armor should cover the entire body with adequate padding to cover vulnerable parts and protect against chafing. The lighter the armor is, the easier it is for the user to wear. Depending on your setting's level of technology, the uniforms can be thinner and sleeker or bulky and low-tech.

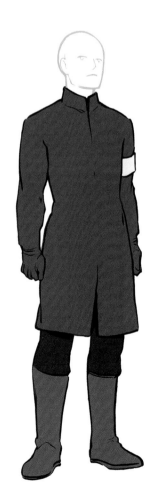
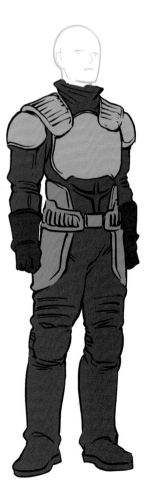
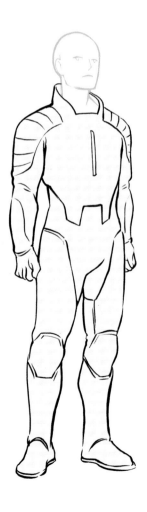

Male vs. Female Armor

Creating differences in male and female armor isn't necessary. Not only does a breastplate with space for each breast look silly, the shape causes the armor to be less effective. In standard armor, blows are deflected to the outside of the body. With frivolous breast shapes added, those blows may instead be drawn inward due to the dips in the armor, increasing the chance for harm. Most female athletes wear sports bras to compress their chests. The same concept can be applied here so female enforcers can gear up and beat the rebel forces down.

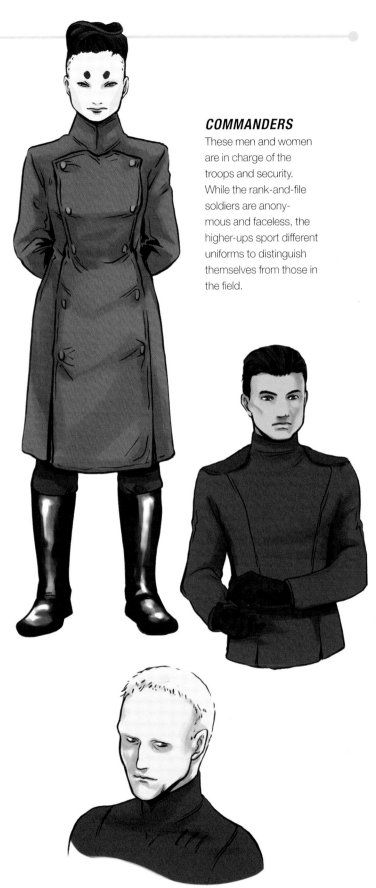

COMMANDERS

These men and women are in charge of the troops and security. While the rank-and-file soldiers are anonymous and faceless, the higher-ups sport different uniforms to distinguish themselves from those in the field.

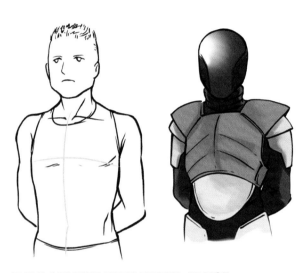

MALE SOLDIER WITH FITTED ARMOR

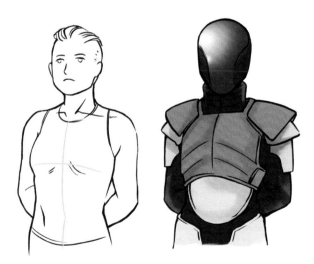

FEMALE SOLDIER WITH FITTED ARMOR

Servants

The city center isn't populated entirely by the well-to-do. Their servants live here, too, dwelling alongside the wealthy in order to do the hard work and keep the upper crust happy. Compared to their employers' clothing, the uniforms they wear are simply constructed and can be used to fit various body types without tailoring.

KEEP IT SIMPLE

Create a servant's uniform with a simple design; most employers won't pay for something more elaborate. For a plain look that's easy to replicate, start with two sheets, sew some of the sides and leave openings for the head, arms and legs.

HEADGEAR

Hats and other head pieces are a good way to round out the uniform. Some serve functional purposes, like keeping hair out of a cook's face or keeping dust out of a maid's hair. Others are merely for looks.

TIE IT OFF

If you want to add more definition, include a belt to cinch in extra fabric at the waist.

SERVANT PALETTE

When selecting your servant color palette, opt for simple and neutral. These clothes are meant to make servants look uninteresting and blend into the background—and most employers won't pay for expensive dye.

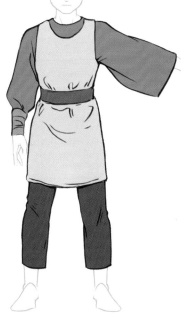

ADD LAYERS

For something a little more complex, layer simple tunics or jackets on top. This results in a more put-together look without making the design of any of the individual layers more elaborate.

BY DESIGN

With a servant's uniform, everything depends on what the employer wants his or her servants to look like. Determine what the goal is and then build your design from that central concept.

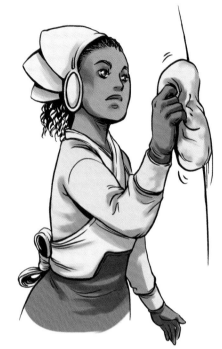

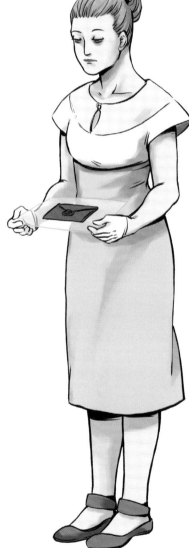

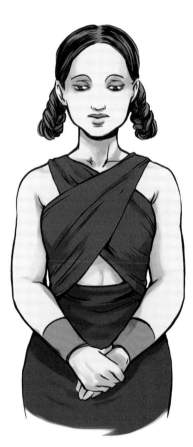

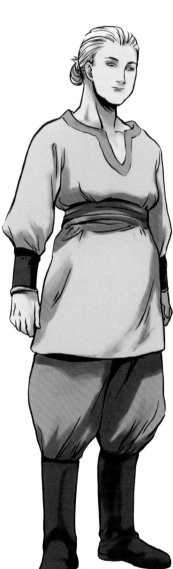

NOT ALWAYS PLAIN

If a servant is going to be somewhere visible, like serving drinks at a party, the employer might want to show off a nicer dress uniform. After all, if they have money to throw away on their servants' clothes, what must that say about their personal wealth? In this case, it's okay to add some decorative elements or a more elaborate hair style.

The Rebellion Underground

Away from the city center, life is much less the glitz and glamour of the obscenely wealthy and much more the daily grind of doing thankless work to survive. From birth, the odds are stacked against those born into the wrong locale; there is no escape, no upward mobility and often not even the means to live comfortably from day to day. It's little surprise that the determined few have taken it upon themselves to stage a rebellion, intent on turning the dystopia's harsh measures and cruel politics upside down.

UNDERGROUND PALETTE

For this palette, select colors from the natural world, ranging from the off-whites of cotton, wool and linen to dyes from plants and minerals. Do a little research to see what's available; nature provides a wider range of colors than you'd expect.

MADE BY HAND

In contrast to the sleek, manufactured look of clothing in the city center, here on the outskirts try to include more homemade garments. Knitted, crocheted or homespun fabric will lend your characters a touch of seeming self-sufficiency.

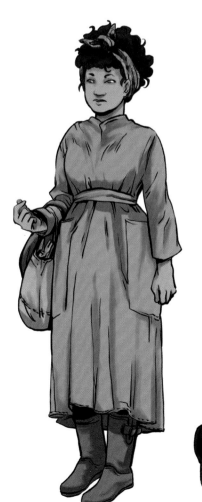

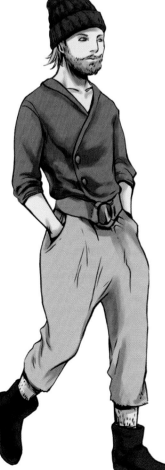

PRACTICAL IS FASHIONABLE

When designing your style, keep in mind everyday use. Characters here can't afford tailored clothes, so belts can help with pants or skirts that don't fit perfectly. Some people may prefer dresses, but they get worn to work, not a night out on the town. Try adding large pockets to provide convenient storage and make them more practical for the wearer.

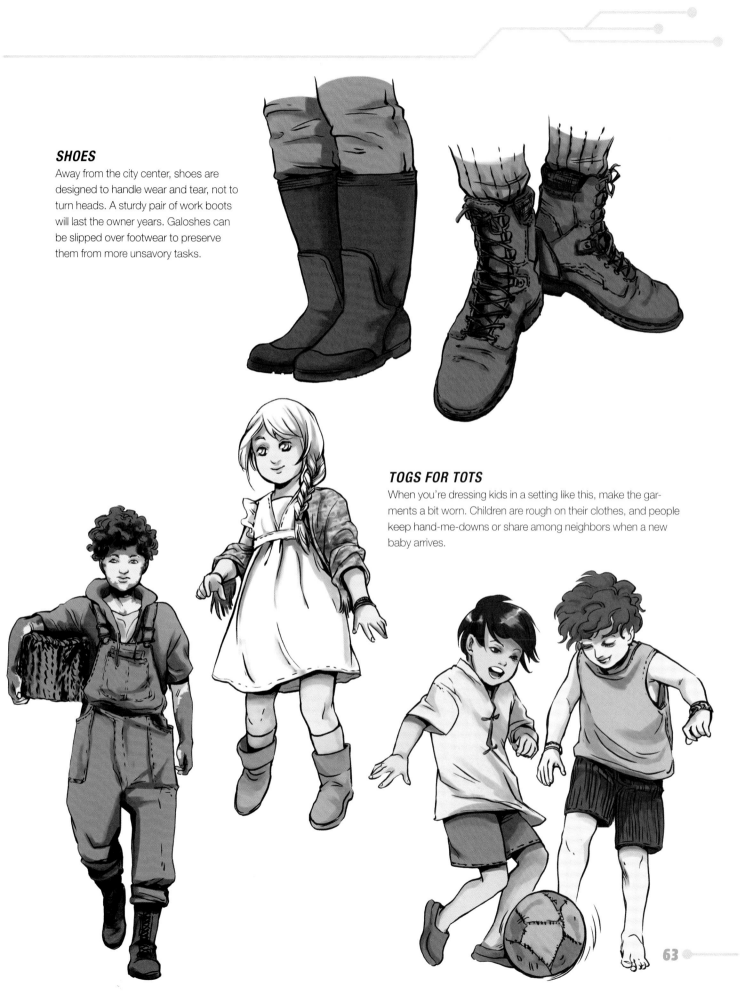

SHOES

Away from the city center, shoes are designed to handle wear and tear, not to turn heads. A sturdy pair of work boots will last the owner years. Galoshes can be slipped over footwear to preserve them from more unsavory tasks.

TOGS FOR TOTS

When you're dressing kids in a setting like this, make the garments a bit worn. Children are rough on their clothes, and people keep hand-me-downs or share among neighbors when a new baby arrives.

THE REBEL LEADER

The Rebel Leader never asked for this job. She just wanted to keep her head down and stay out of trouble, but the best-laid plans often go awry. Now she's the head of the underground rebellion, and even though she wasn't planning on taking part, she's uniquely suited for the job. She's a natural: strong, capable and charismatic. The dystopia's Have-nots have been downtrodden for so long that they've started to forget what hope looks like—but with the Rebel Leader carrying the banner, there just might be light at the end of the tunnel.

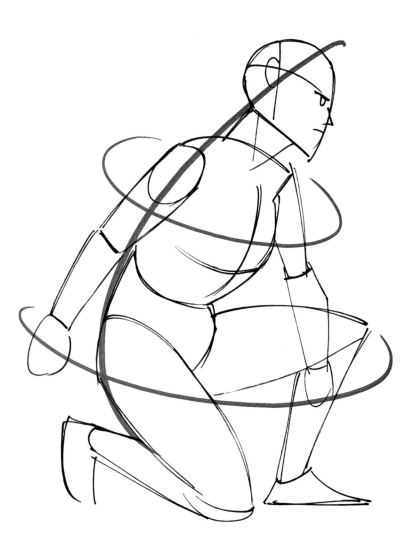

1 STRIKE A POSE

Start with your sketch. For the Rebel Leader, pick something action-oriented. She's crouched low to the ground, getting ready to spring up for an attack.

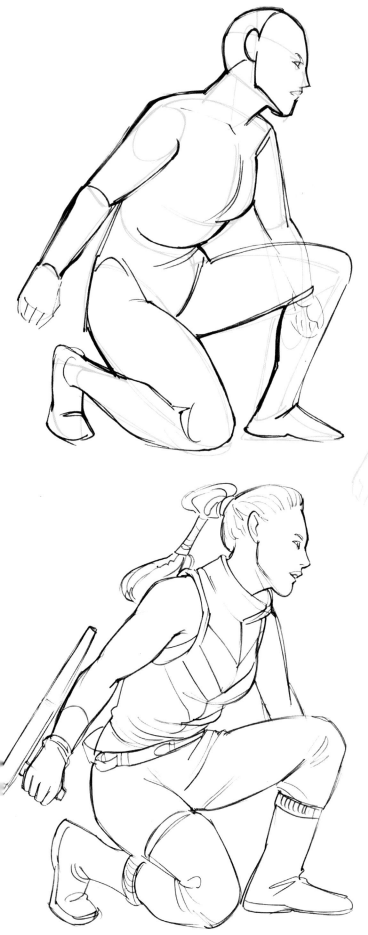
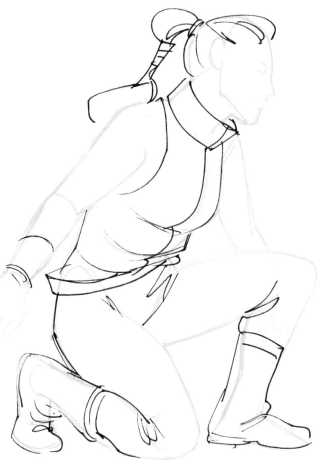

2 FILL IT IN
Clean up the lines in your sketch. Edit the anatomy to suit your character and start adding in the first bits of detail. Also keep an eye out for any changes you can make to improve the anatomy from your initial sketch. In this version, her left leg is a little longer than it was originally.

3 DRESS YOUR CHARACTER
Sketch in the clothes and hair, paying attention to what suits the character's personality. Her hair is tied back so it won't get in the way, and she has no loose clothes to get caught in the middle of a fight.

4 ADD DETAIL
Prep your piece for inking by working in more detail. This is a good time to start putting in small touches like the lines on her vest or the texture on the rim of her boots.

She prefers a stealthy combat style, so her weapons should reflect that. Tonfas are small, light and quiet, which is perfect for what she needs.

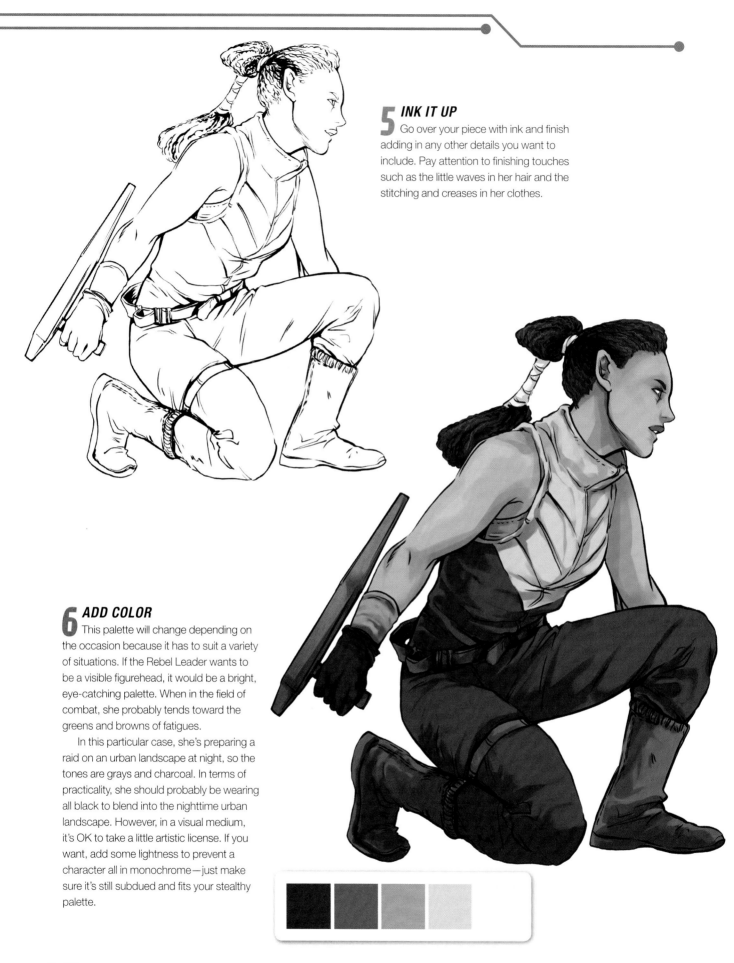

5 INK IT UP

Go over your piece with ink and finish adding in any other details you want to include. Pay attention to finishing touches such as the little waves in her hair and the stitching and creases in her clothes.

6 ADD COLOR

This palette will change depending on the occasion because it has to suit a variety of situations. If the Rebel Leader wants to be a visible figurehead, it would be a bright, eye-catching palette. When in the field of combat, she probably tends toward the greens and browns of fatigues.

In this particular case, she's preparing a raid on an urban landscape at night, so the tones are grays and charcoal. In terms of practicality, she should probably be wearing all black to blend into the nighttime urban landscape. However, in a visual medium, it's OK to take a little artistic license. If you want, add some lightness to prevent a character all in monochrome—just make sure it's still subdued and fits your stealthy palette.

Dirty Jobs

It's a dirty job, but someone's got to do it—and the ones in power, living the life of luxury in the city center, are going to make sure it gets shunted off onto someone else. In an urban dystopia, work conditions are poor, and there's next to no consideration for the comfort or safety of the workers. Filthy uniforms and unfortunate industrial accidents are the standard, not the exception.

STAINS
Create stains by inking with a simple hatching technique. If you want darker, dirtier stains, layer some crosshatching on top of your original lines.

ROUGH ON THE HANDS
What does your character do for a living? If they're a laborer from the working class, their hands ought to show it. Be sure to include rough knuckles, callouses and dirt ground into the nails.

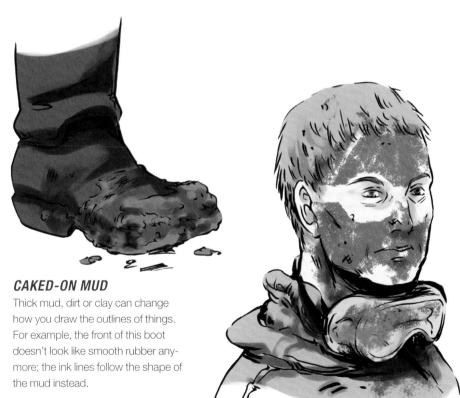

CAKED-ON MUD
Thick mud, dirt or clay can change how you draw the outlines of things. For example, the front of this boot doesn't look like smooth rubber anymore; the ink lines follow the shape of the mud instead.

SHOWCASE DIRT WITH COLOR
Try showing dirty patches with color. Dark smears of grime stand out when they're in contrast to a lighter hue behind them.

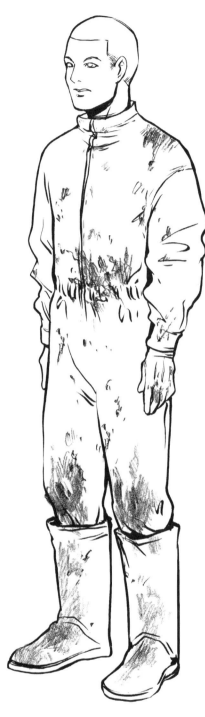

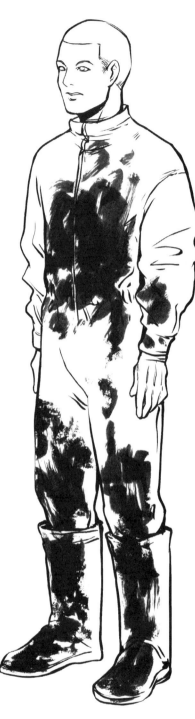

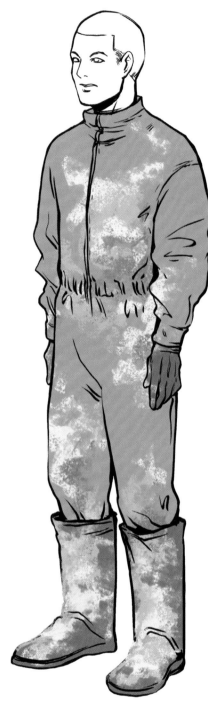

CROSSHATCHED DIRT
Show darker stains by going over them repeatedly with crosshatching.

INKED DIRT
Blacking out entire portions of the drawing works if you want a completely filthy look.

COLORED DIRT
If you find it easier, skip inking your stains completely, then add them later when you color.

BRUISING

Use the same crosshatching technique for bruising that you would for stains. It's all about the context. If the eye underneath that crosshatching is swelling, the viewer perceives it as a black eye instead of dirt.

EVEN SCARS

To make an even scar, like a character might receive from a blade, draw the cut and the dots where the stitches went. As it heals, the scar pulls at the normal skin on the edges, so it looks a little jagged.

UNEVEN SCARS

Determine what caused the scar before you start drawing; that will affect the shape. Keep in mind that scar tissue is lighter and looks shinier than the usual skin tone, and address the differences while coloring.

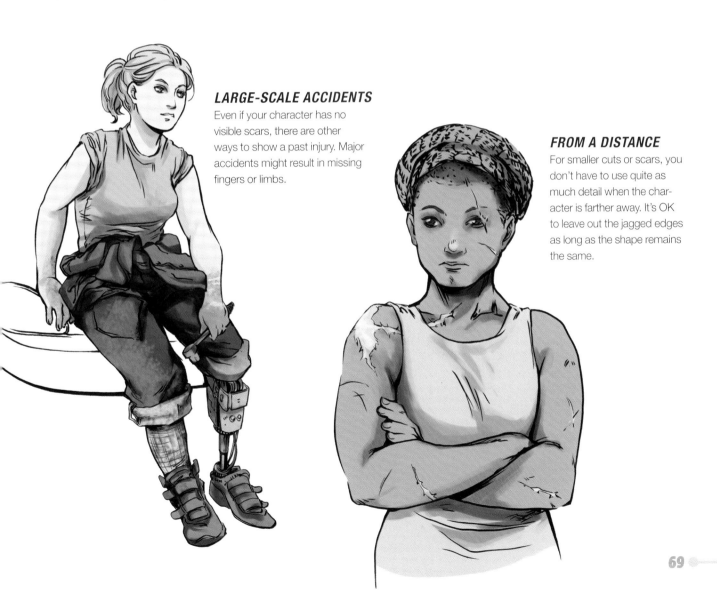

LARGE-SCALE ACCIDENTS

Even if your character has no visible scars, there are other ways to show a past injury. Major accidents might result in missing fingers or limbs.

FROM A DISTANCE

For smaller cuts or scars, you don't have to use quite as much detail when the character is farther away. It's OK to leave out the jagged edges as long as the shape remains the same.

Looking to the Past

What people wear is a highly personal choice, and family history and cultural background can contribute to a character's sense of self. In a setting like the urban dystopia, in which history has been rewritten to suit those in charge, honoring the past or the traditional can be a rebellious act. While designing clothes for the underground, keep in mind your character's family history, cultural background and what he or she might choose as a symbol of freedom or self-expression.

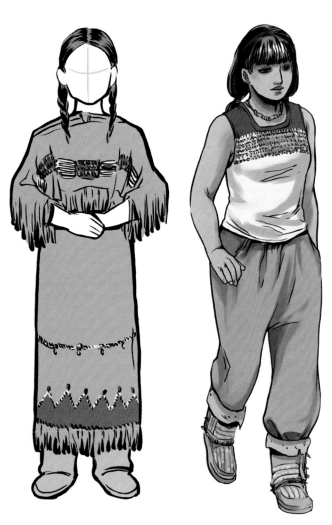

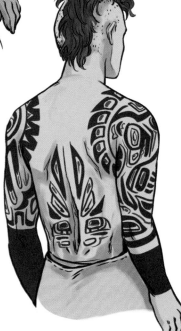

HAIDA TRIBE INSPIRED ART

Different cultures have unique art styles that offer an incredible variety of distinct appearances. Research the art of your character's culture, and if your character is proud of his or her heritage, put it on display. Take inspiration from the style and colors, then work them into your clothing designs. Art that is especially important to your character might make an appearance directly on the body as a tattoo.

CHEYENNE PLAINS TRIBE DRESS

Start by learning the traditional dress of someone from your character's culture and then decide if your character would incorporate certain elements into his or her personal style. Here, the distinct beading pattern and colors supplement a contemporary shirt that suits the dystopian setting.

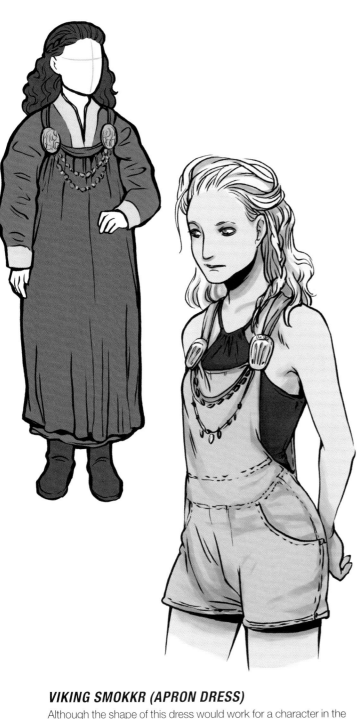

RUSSIAN PEASANT

In some cases, with a simple source material, it's easier to take the intent of the clothes rather than the aesthetic. Try examining a traditional outfit for its functional purpose and apply that to your new design instead. In the case of the tunic and pants worn by a Russian peasant, the main goal was to keep warm. A future equivalent might be something closer to a puffy vest, warm wool socks and thick winter boots. It's up to you how little or how much you want history to bleed into your designs.

VIKING SMOKKR (APRON DRESS)

Although the shape of this dress would work for a character in the rebellion underground, it's okay to distance it from the original inspiration. This isn't a historical drama; it's a future dystopia. Try mixing contemporary overalls with the traditional jewelry to create a new style. You wouldn't typically see it in our current fashion, but it might be a believable combo in a future that looks to the distant past.

THE CON MAN

The Con Man started life as a street kid and he learned to lie for his supper early on. As he grew older, the lies only grew more elaborate. Now he flits between the city center and the outlying slums with a charming smile and whatever pretty deception he needs to put money in his pocket. If asked about the rumors that his ill-gotten gains are bankrolling the rebellion, he'd swear they were nothing more than that—rumors. What do you take him for, anyway? Some kind of sap?

1 STRIKE A POSE

Draw up a few sketches, then pick the one you like best. For the Con Man, who's charismatic and personable, choose a relaxed pose. His posture is a little flirty, with his hip jutted out as he chats away.

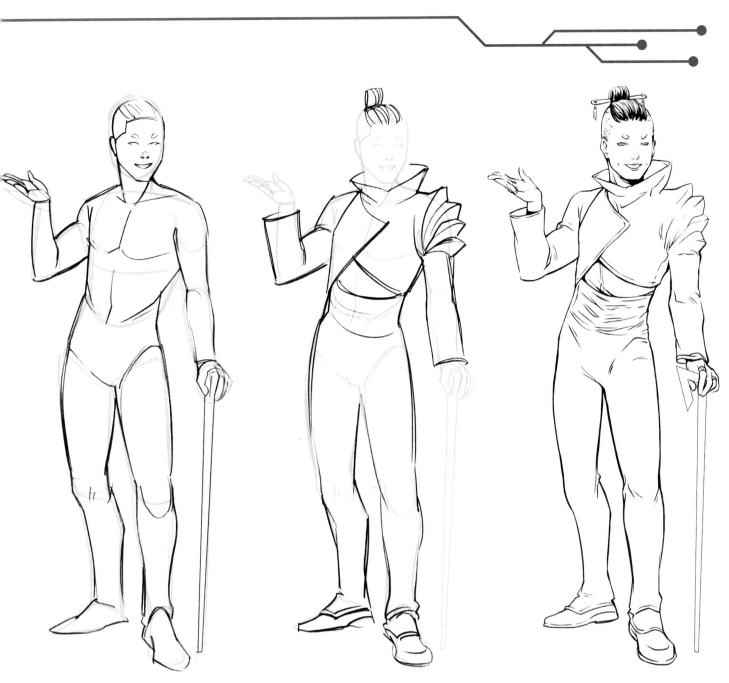

2 FILL IT IN

Take a good look at your original sketch and identify the areas you can improve, then fix the proportions. Here, in comparison to the original, the head is smaller, the shoulders are slightly raised and some of the limbs are a bit longer.

3 DRESS YOUR CHARACTER

Decide what your character will be wearing. The Con Man spends a lot of time in the city center talking targets out of money, so dress him in the same style as the rich folks he wants to impress. His shirt and pants are pretty simple, but they're very colorful. Use the jacket and hair to add a bit more flair.

4 ADD DETAIL

Start working in the personal touches that will bring your character to life. For a social character like the Con Man, pay extra attention to his face and mannerisms because they're vital to his personality.

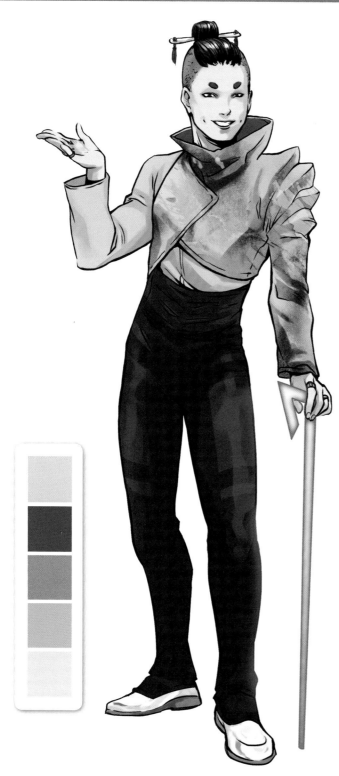

EVERYDAY WEAR

The Con Man runs his schemes in the city center, but he lives in the slums where he grew up. He's adept at blending in no matter where he is, so try designing a casual outfit for him, too—something he can wear when he's not showing off for targets.

5 ADD COLOR AND ACCESSORIES

Select a palette to match the city center's aesthetic, since that's where the Con Man does most of his work. Opt for bright, highly saturated colors that catch the eye.

Break up the large blocks of color on his clothing by working in some patterns. You can also give him a touch more flair (and practice an earlier lesson) by adding a self-lighting walking stick.

THE REPORTER

Not everyone who is trying to make a difference is cut out to be part of the rebellion. The Reporter always had a way with words, and she plans to show the tyrants in the city center that the pen is mightier than the high-tech laser weapon. Bright, tenacious and stubborn, the Reporter is willing to follow a lead to the ends of the earth if it will bring her closer to the truth.

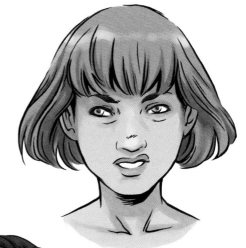

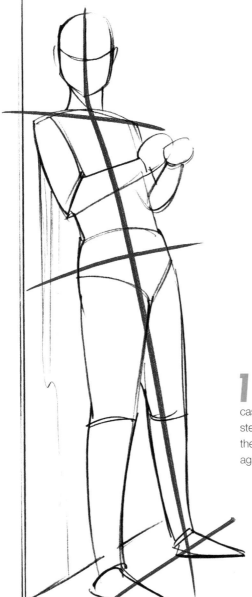

1 STRIKE A POSE

The Reporter can get in people's faces and press her case, but she knows that there is a time and a place to step back and listen. She's in listening mode now; slant the line of her body so it looks like she's leaning casually against the wall.

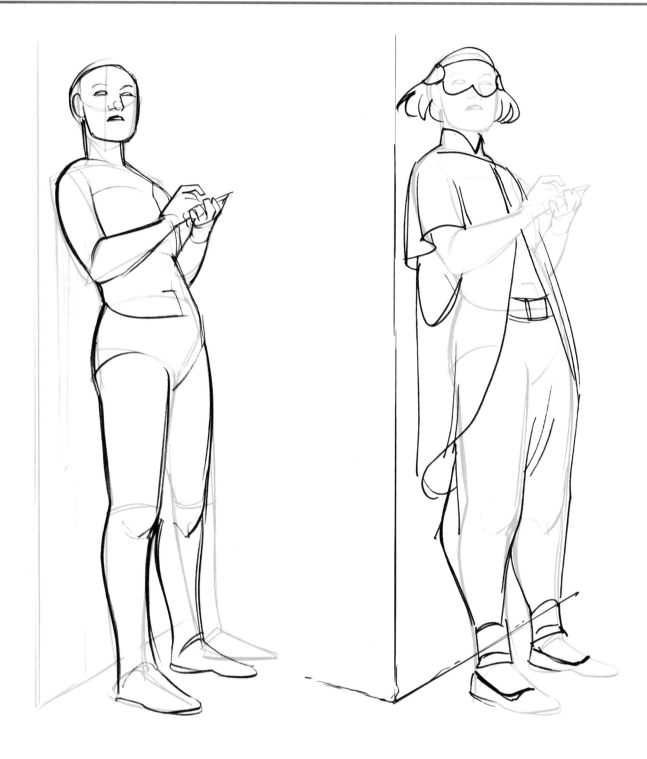

2 FILL IT IN

Evaluate your pose and make adjustments to her anatomy. Plant her feet closer together to make the stance more casual. Turn her head a bit away from the action. She's paying attention, but she wants to be discreet. The first pose was a bit too obvious for what she's trying to accomplish.

3 DRESS YOUR CHARACTER

Like the Con Man, the Reporter wanders through the city center to get what she wants, blending in with the privileged to dig for information. She's not trying to catch attention, though. She only wants to be a face in the crowd, so don't make her clothes too extravagant.

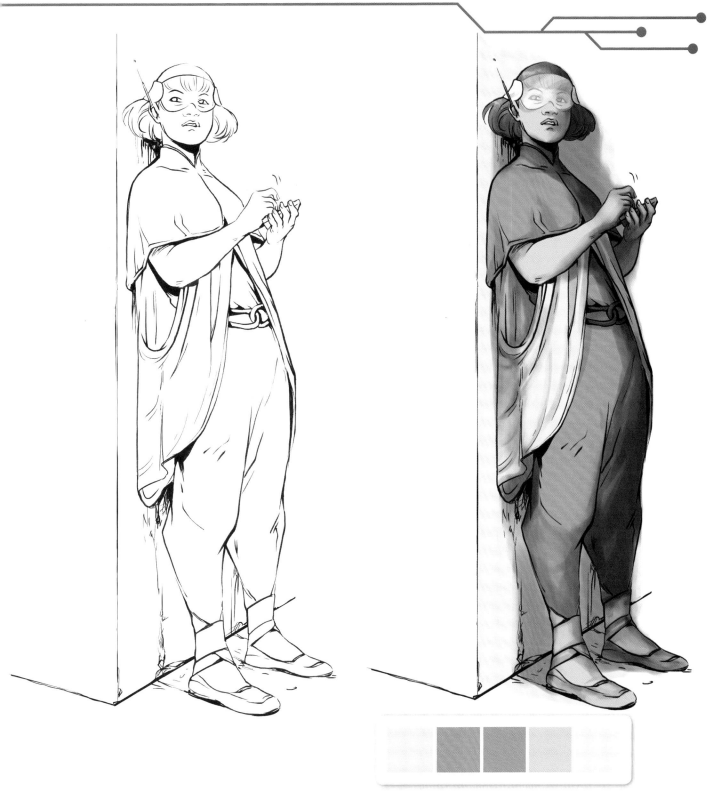

4 ADD DETAIL

Try to strike a balance with her outfit. It should match the city center's aesthetic, but not be particularly loud or remarkable. She's passing herself off as just another citizen, casually typing on her notepad. Make sure to include storage space for her equipment, though. She'll need notes, pens and listening devices (like what she's got in her ear). The extra room in her baggy cape provides plenty of space to stow everything.

5 ADD COLOR

While you're designing this palette, pick colors that will blend well with the bright hues of the city center, but be careful not to use anything too striking or memorable. Her goal is to hide in plain sight, and her palette should reflect this.

Use your palette to fill in her outfit, then add a few finishing touches to help with her disguise. The visor helps to obscure her face and eyes, and the colored wig keeps her natural hair hidden.

4 *iRobot*

While the term *sci-fi* encompasses a multitude of styles, settings and accessories, one unifying theme is that it employs technology you don't see on modern-day Earth. Yes, that means gadgets. Sometimes, it even means spaceships. But mostly, it means that timeless sci-fi staple—the robot. Like the genre itself, robots come in all shapes and sizes, from the cute and helpful house robot to the massive mecha so popular in Japanese manga. Depending on your setting, the aesthetic of your technology can vary greatly, but knowing a few basics can help you get started.

Exosuits

Exosuits are robot suits worn directly over the human form. They do anything people can do—but better. In addition to being an effective defensive shell, they enhance the wearer's strength, increase endurance and house high-tech weapons.

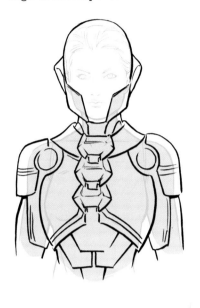

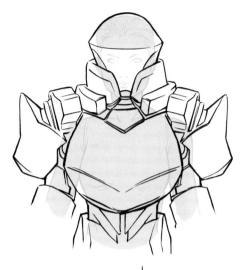

ONE SIZE DOES NOT FIT ALL

Styles of exosuits can vary as widely as styles of clothes do. You can adjust size as well as appearance (the way you did for the body armor in chapter 3), but make sure to leave room for padding, wires and circuitry. Higher levels of technology mean less space is needed on the interior, so that affects the look of the suits.

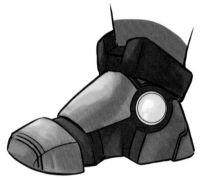

BREAK IT DOWN

If designing an exosuit all at once is daunting, start simple with one body part at a time. We'll use a foot as an example, but you can apply these techniques to any individual portion of the suit.

First, reduce the body part to basic shapes. For the foot, add a circle in red to represent the ankle.

KEEP IT UNCOMPLICATED

One option is to go simple and sleek, following the shape of the foot. On an exosuit like this, the sole is similar to something you'd see on a running shoe.

A LITTLE FANCIER

You can also play off of the angular shapes of the foot and add decorative elements. The circular portion near the ankle is common to both examples, but the designs look completely different.

INSPIRATION FROM LIFE

Try taking inspiration from existing clothing and shoes. For example, a common style of running shoe with a Velcro strap could easily be converted to something high-tech.

Try playing up the angles. Instead of curves, use straight lines. Exaggerate the proportions of the shoe's collar and the part that replaces the Velcro strap to make it look heavier.

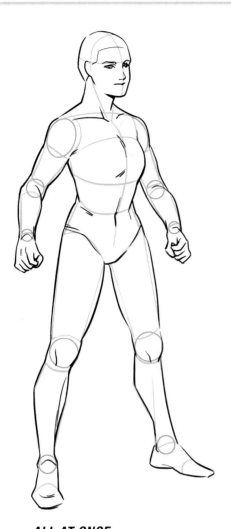
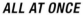
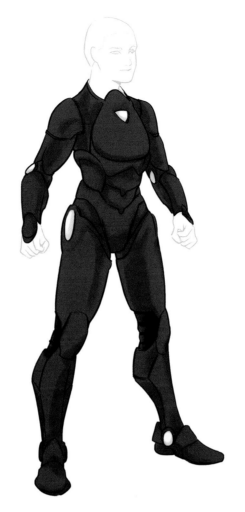
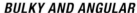

ALL AT ONCE

Another way to design your exosuit is to tackle everything at once. To use this method, start by sketching the wearer's body in simple shapes and lines. Draw the joints in red. When you add the suit on top, these will show you the places where you need to add a break in the metal to allow the exosuit to bend.

SLEEK AND GLOSSY

Keep the lines smooth and follow the shape of the body, but break the rigid part of the armor into separate pieces. This allows your character to move at the shoulders, the elbows and behind the knees. The upper chest is a solid piece, but there are individual plates on the stomach so she can bend forward.

BULKY AND ANGULAR

If you want your suit design to be more bulky, try sketching the body with linear angles and use that as a base to create your exosuit. Sizing up the plates to encase the body can provide a good starting point.

IT'S UP TO YOU

Exosuits can look however you want them to look. They can be puffy like astronaut suits or personally customized or anything else you can dream up. Just keep an eye out for functionality, and the sky's the limit.

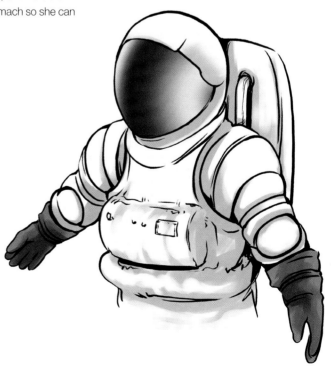

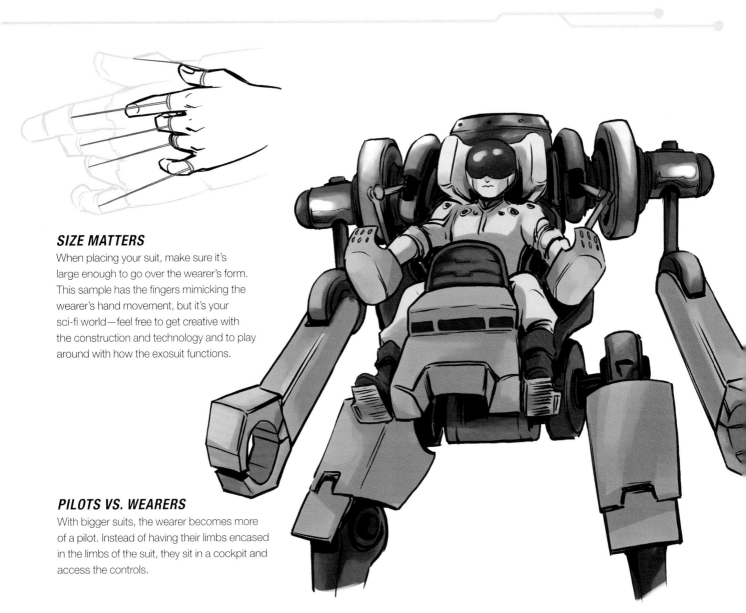

SIZE MATTERS

When placing your suit, make sure it's large enough to go over the wearer's form. This sample has the fingers mimicking the wearer's hand movement, but it's your sci-fi world—feel free to get creative with the construction and technology and to play around with how the exosuit functions.

PILOTS VS. WEARERS

With bigger suits, the wearer becomes more of a pilot. Instead of having their limbs encased in the limbs of the suit, they sit in a cockpit and access the controls.

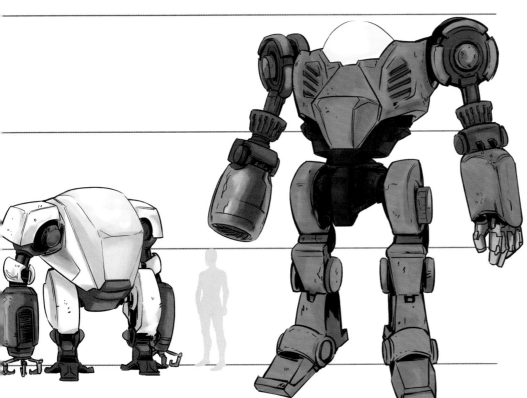

A QUESTION OF SCALE

You can increase the size of your mechanized suits as much as the setting allows. Try drawing them beside a human of normal height to get a feel for the scale.

DESIGNING AN EXOSUIT

When your characters are ready to suit up and save the world, make sure they're equipped to do it. Start by designing an exosuit that's practical and aesthetically appealing.

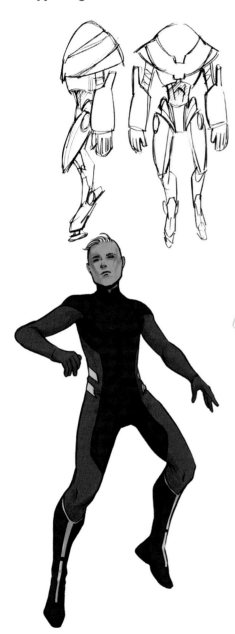

1 START WITH A SKETCH

When designing an elaborate costume, it always helps to create a rough sketch of it first. This lets you fine-tune your design without a huge time sink; if you decide you don't like it, you haven't wasted hours getting every angle perfect. Try sketching it from the front, the back and the sides. When you come up with one you like, keep your initial design on hand for easy reference.

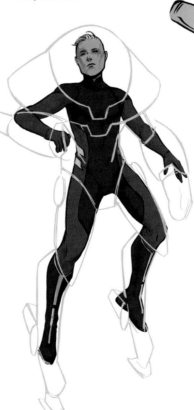

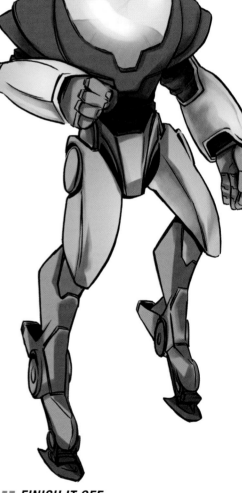

2 DESIGN THE BOTTOM LAYER

Figure out what your character wears underneath the exosuit. Keep the outfit fairly tight so it won't catch on anything, bunch up or be uncomfortable.

3 ADD YOUR SKETCHED SUIT DESIGN

Work in the suit design you sketched earlier. It should sit over the body, and the limbs of the suit should correspond to the character's limbs.

4 FINISH IT OFF

When you like what you have, commit to your design. Now you can fill in the details, ink the drawing and polish it up.

Prosthetic Parts & Enhancements

Not all wearable tech has to be full-body. In fact, in a setting with advanced robotics, it should be expected that prosthetic parts and enhancements for regular people have kept up with technology. When you're designing characters, keep in mind the new array of options, and feel free to make use of them.

MODERN PROSTHETIC LIMBS

Prosthetic limbs already exist in our world today, and their technology and appearance is constantly evolving. Try looking at existing examples for inspiration.

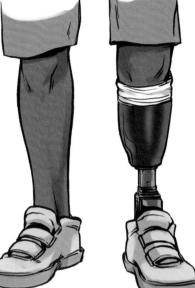

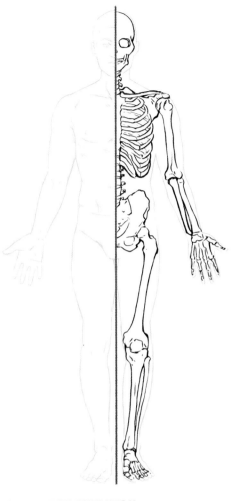

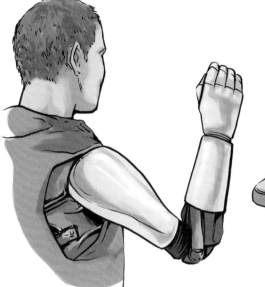

STUDY THE SKELETON

A good base for creating any prosthetic part is the human skeleton. It's what holds the body up. Since your prosthesis is providing essentially the same function, studying the way the skeleton works will give you an understanding of what the replacement should do.

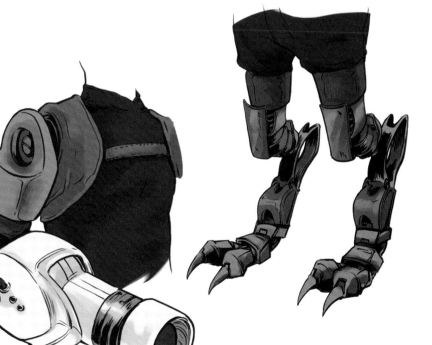

THE FUTURE IS NOW

The modern is a good starting place, but it doesn't have to be the finish line. Not all prosthetic parts have to be analogs for human limbs. Remember that in a sci-fi setting, it's OK to use technology beyond what current science has discovered.

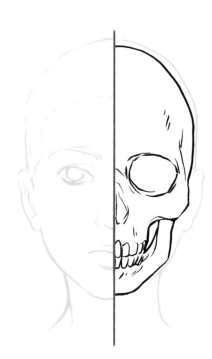

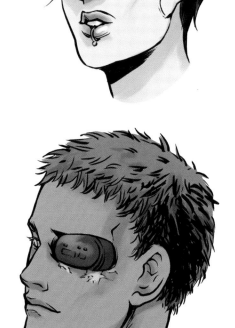

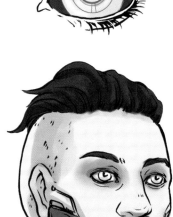

STUDY THE SKULL

Before you try drawing face prostheses, study the human skull and then sketch it out. Placing the skull beneath the face will illustrate the natural curves and hollows; it will also give you an idea of what parts can be replaced.

FACE PROSTHESES

In today's world, facial prosthetic parts already exist. A lot are discreet by nature—designed to disguise injuries and scars—but in a sci-fi world, they don't have to be subtle. Depending on the setting, facial prostheses might be eye-catching by design or even tailored to a wearer's stylistic whims.

HIGH-TECH ACCESSORIES

As you consider enhancements for your characters, remember that you aren't bound by existing technology. In the future, characters might wear high-tech jewelry, get manicures with computer-chipped nails or even work nanotechnology into the ink of their tattoos. If high-tech body art could harness the bio-electric energy of our bodies, low cell phone batteries would be a thing of the past. (If the future has cell phones, that is.)

Personalized Design

Prostheses can be as varied as their wearers. They should be functional, but that doesn't mean they can't be decorative as well.

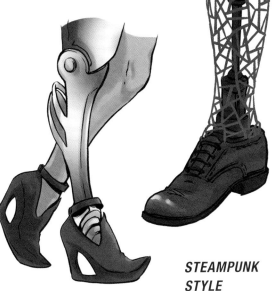

A PEEK INSIDE

The cage work on this prosthesis is shaped like the lower leg, but you can see through it to the metal base.

PRETTY PAINT JOB

Just like clothing, prosthetic limbs can be styled to suit the wearer.

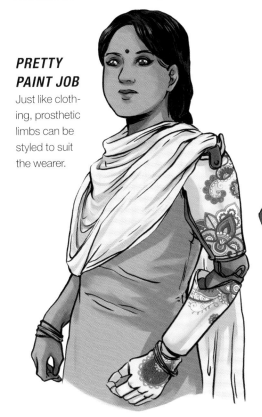

CHIC AND SMOOTH

A sleek lower leg with a decorative element to represent the calf muscle offers a simple look.

STEAMPUNK STYLE

Try something that's high-tech but mimics the low-tech—with wire pulleys for show.

Crafted for a Purpose

People have a lot of pastimes, and that doesn't change just because they need a prosthetic limb. To accommodate your characters' hobbies, feel free to create a mechanized limb specifically for an activity they enjoy. To get you started, take a look at these examples of designs that already exist in our contemporary world.

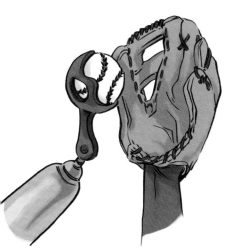

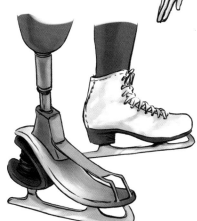

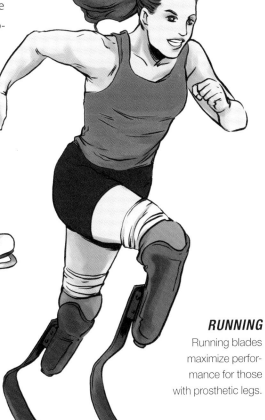

BASEBALL

This ball-shaped catcher substitutes for a mitt.

ICE SKATING

Except for the laces, this prosthetic foot looks just like an ice skate.

RUNNING

Running blades maximize performance for those with prosthetic legs.

Put the "Fi" in Sci-Fi

Now that we've looked at the ordinary, go crazy and try for the extraordinary. In a sci-fi setting, it's OK to dream big. What makes sense for Earth isn't necessarily the same thing that makes sense for a distant planet or outer space or a world thousands of years in the future.

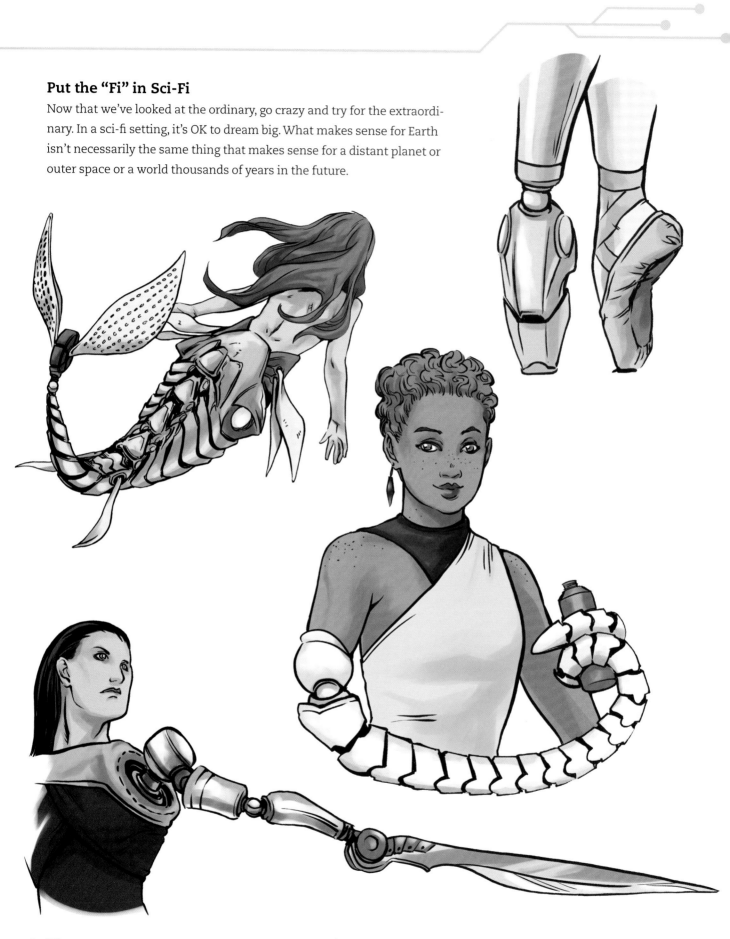

THE MERCENARY

In an intergalactic space-age setting, criminals don't just leave town—they skip the planet. That's when the Mercenary gets called in to pick up the ones who have outrun the long arm of the law. With every job he completes, he sinks a little bit of his profit into a new prosthesis or some shiny new high-tech weaponry. Now, after twenty years on the job, his closest friends joke that he's a walking arsenal—and most of the criminals he rounds up take one look and wave the proverbial white flag.

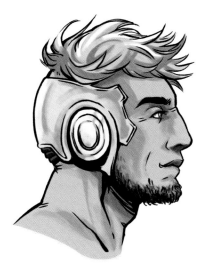

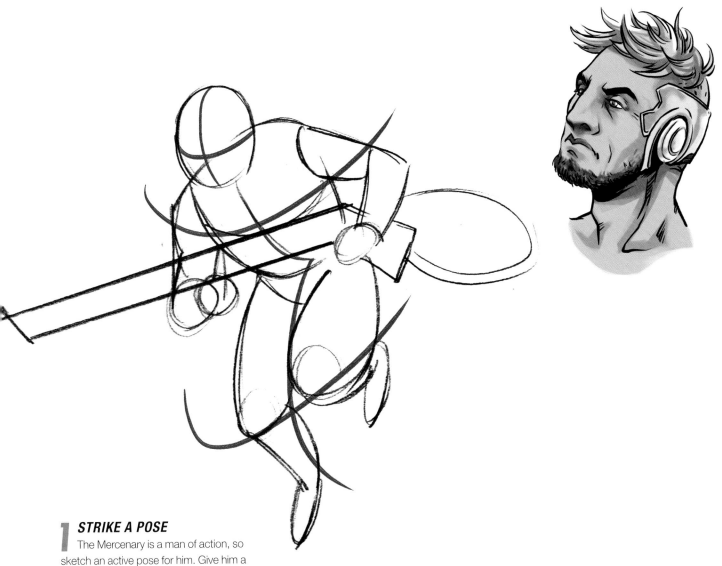

1 STRIKE A POSE

The Mercenary is a man of action, so sketch an active pose for him. Give him a purposeful, forward-moving stance—he's a man on a mission. Build a base for his compact, barrel-shaped frame. Make sure he has a solid grip on his rifle, too.

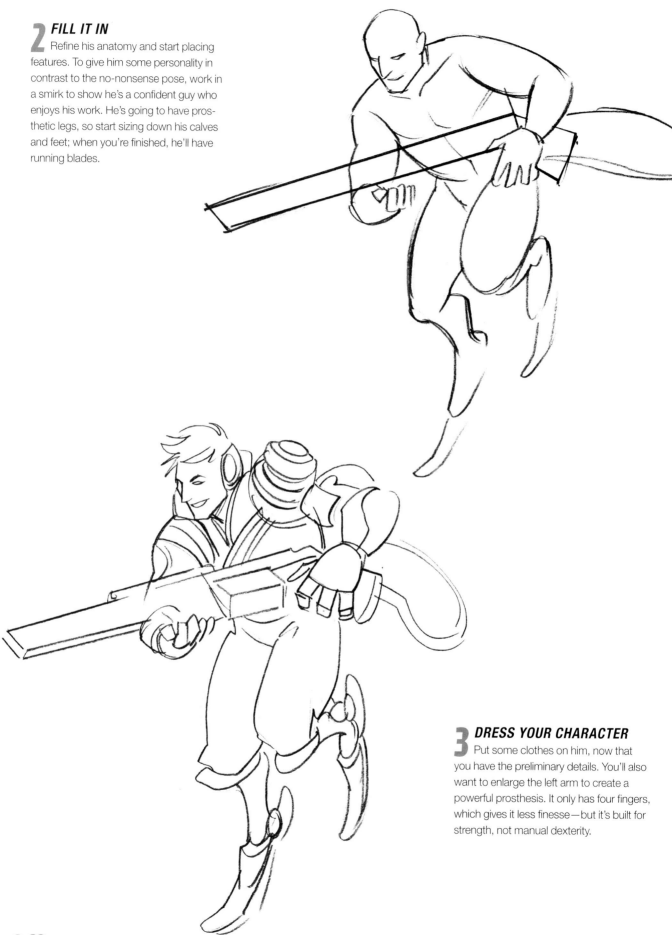

2 FILL IT IN

Refine his anatomy and start placing features. To give him some personality in contrast to the no-nonsense pose, work in a smirk to show he's a confident guy who enjoys his work. He's going to have prosthetic legs, so start sizing down his calves and feet; when you're finished, he'll have running blades.

3 DRESS YOUR CHARACTER

Put some clothes on him, now that you have the preliminary details. You'll also want to enlarge the left arm to create a powerful prosthesis. It only has four fingers, which gives it less finesse—but it's built for strength, not manual dexterity.

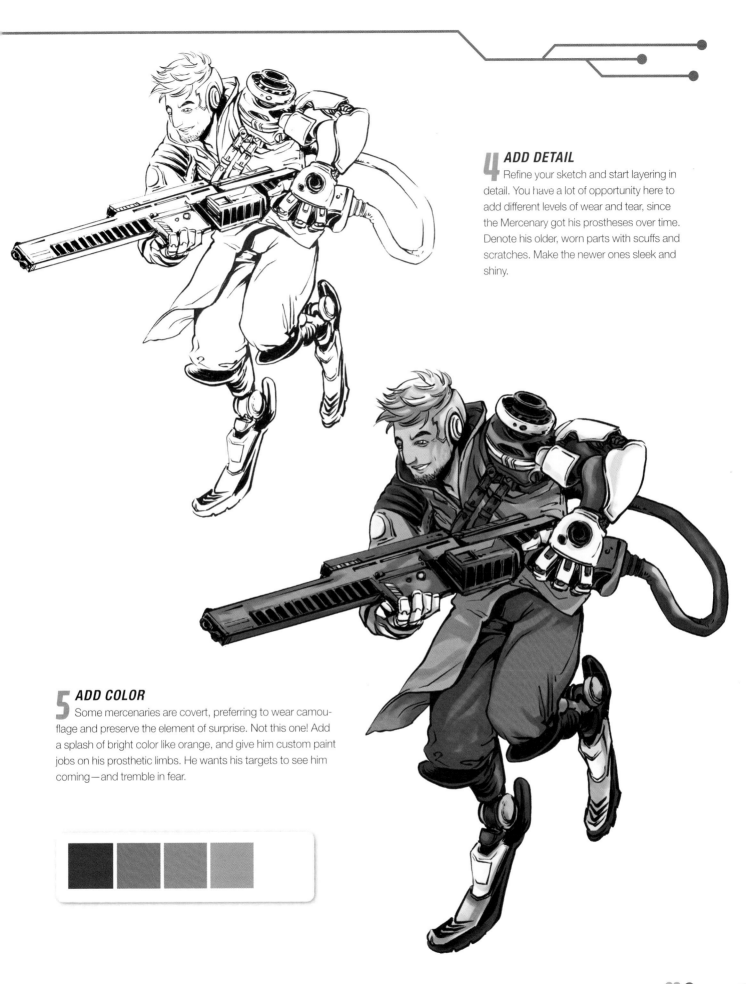

4 ADD DETAIL

Refine your sketch and start layering in detail. You have a lot of opportunity here to add different levels of wear and tear, since the Mercenary got his prostheses over time. Denote his older, worn parts with scuffs and scratches. Make the newer ones sleek and shiny.

5 ADD COLOR

Some mercenaries are covert, preferring to wear camouflage and preserve the element of surprise. Not this one! Add a splash of bright color like orange, and give him custom paint jobs on his prosthetic limbs. He wants his targets to see him coming—and tremble in fear.

Robots

Robots have been a time-honored tradition of science fiction since early in the genre's history. They vary wildly from source to source, offering a huge array of options in terms of looks, attitude and human-like characteristics. Before designing your robot, give plenty of thought to how it functions and the general aesthetic of your setting. With that in mind, start to build.

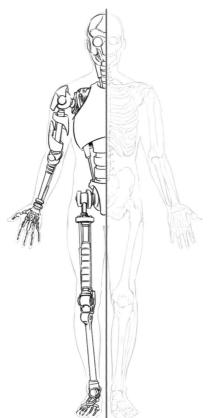

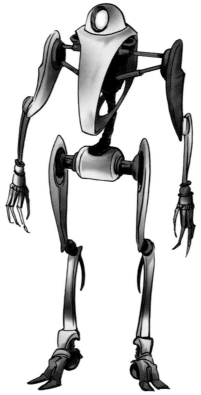

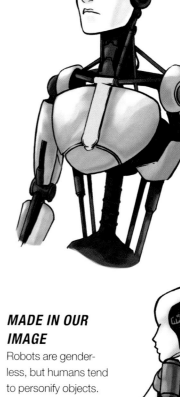

MADE IN OUR IMAGE
Robots are genderless, but humans tend to personify objects. To that end, you might create robots that look distinctly male or distinctly female.

FROM THE BONES UP
When you draw a humanoid robot, the metal frame has to compensate for the work the bones would do in a regular human. Try sketching a human skeleton side-by-side with a mechanical frame to get a feel for how the metal parts will interconnect.

FREEDOM OF DESIGN
Robots don't need the muscle and tissue that humans have, so beyond a metal frame that will hold them up, you have a lot of leeway in their design. Make them as sleek or as cumbersome as you want them to be, and feel free to customize them to the look of your setting.

AN OUTER SHELL
If you want to create a shell to house your robot's vulnerable bits, remember that it doesn't need to be as bulky as the exosuits discussed earlier in this chapter. A robot's shell just has to hold circuits—not a human body.

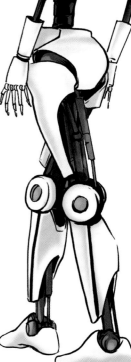

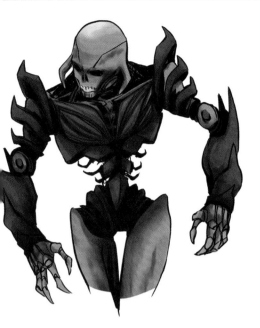

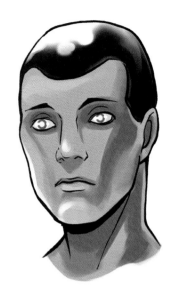

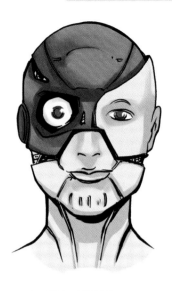

MIX AND MATCH
Accessorize your robot with replaceable panels.

FLEX THOSE METAL MUSCLES
Musculature isn't necessary for robots, but you might want to suggest it anyway. A muscular design plays into the human sense of intimidation, so villainous bots sometimes have bulging muscles or exaggerated, menacing features.

THAT SYNTHETIC LOOK
Give your robot an android look with shiny plastic skin.

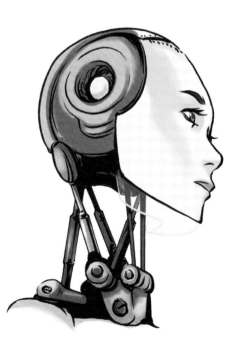

DRESSED FOR SUCCESS
You can make your robots look more human by clothing them—though some will still look mechanical, no matter what they wear. On the flip side, some could easily pass for human, if only they would cover up.

SOME ASSEMBLY REQUIRED
Make your robot a work in progress by going for the half-finished look.

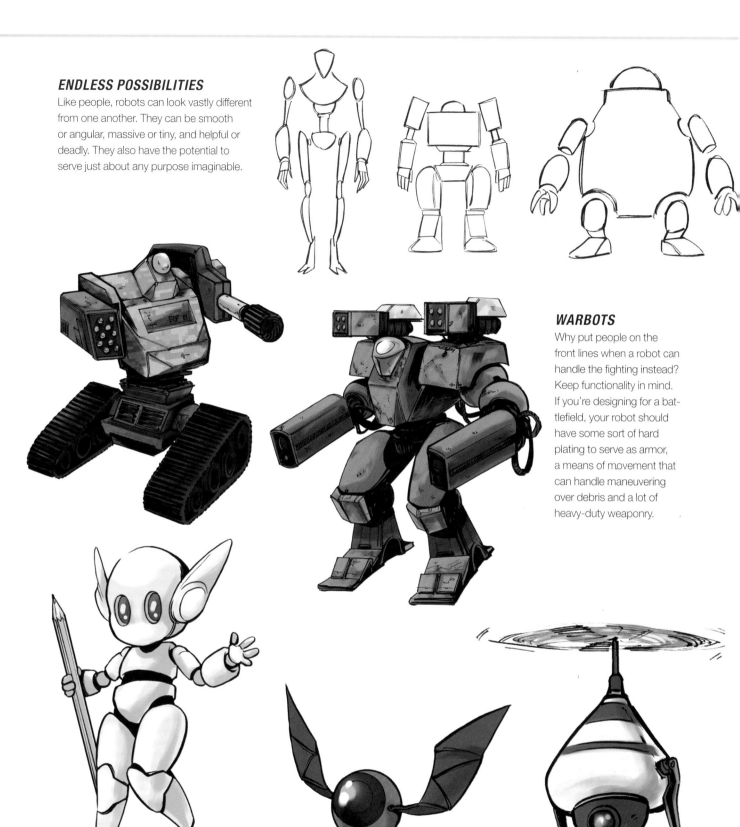

ENDLESS POSSIBILITIES

Like people, robots can look vastly different from one another. They can be smooth or angular, massive or tiny, and helpful or deadly. They also have the potential to serve just about any purpose imaginable.

WARBOTS

Why put people on the front lines when a robot can handle the fighting instead? Keep functionality in mind. If you're designing for a battlefield, your robot should have some sort of hard plating to serve as armor, a means of movement that can handle maneuvering over debris and a lot of heavy-duty weaponry.

TOY BOTS

In a setting where robots are commonplace, even kids have them. Try scaling them down when they're playthings and go for a cute look—remember, they're designed for children.

FLYING BOTS

Do your robots need to get airborne for camera work or to complete a delivery? It's OK to forego a humanoid shape. In this case, a design that's closer to an airplane or a helicopter is probably more effective.

CONSTRUCTION BOTS

Instead of letting workers do the heavy lifting, a high-tech society might pass along construction work to robots. Take a peek at modern-day construction equipment to see current best practices in the field, then outfit your construction bots with whatever parts are most likely to get the job done.

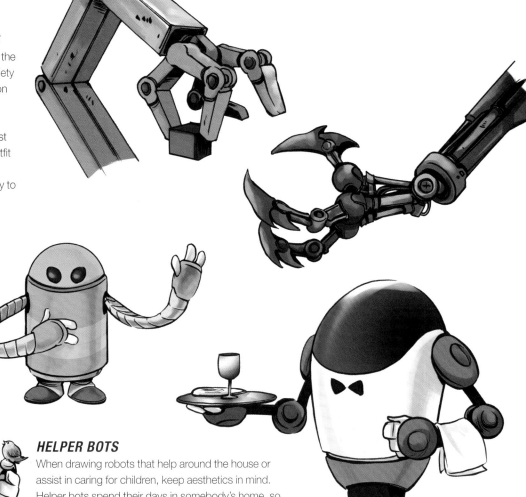

HELPER BOTS

When drawing robots that help around the house or assist in caring for children, keep aesthetics in mind. Helper bots spend their days in somebody's home, so they should be nonthreatening and visually appealing.

SERVICE INDUSTRY BOTS

A robot designed to sell fast food behind a counter doesn't have to be particularly strong or quick. It's serving as the "face" for the company, so give it a more human-like appearance. And remember that corporations will use any inch of real estate they can get their hands on for advertising.

HOSPITALITY BOTS

For a robot that welcomes customers to an upscale hotel, appearance is important. Opt for an appealing, humanoid look, and feel free to experiment with the robot's method of movement. Since this hospitality bot is designed exclusively for use on a polished lobby floor, try an alternate base that will glide or roll.

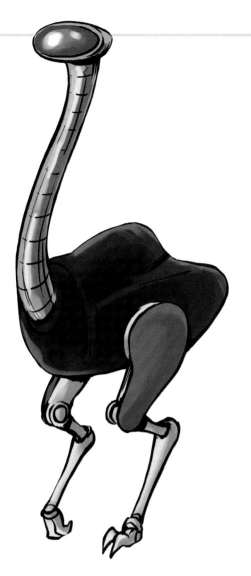

NATURE-INSPIRED BOTS

Not every robot has to be dreamed up from scratch. Modern robotics is already basing designs on the bodies of animals to huge success. Why not try out a few of your own?

Mechanical Malfunction

Robots can suffer from neglect, workplace hazards or just plain wear and tear over time. If your characters don't keep their robots well-maintained, try working some damaged parts into the design.

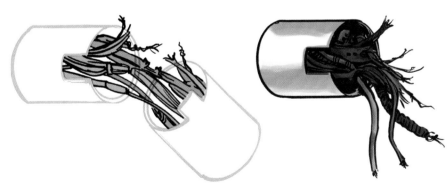

VULNERABLE POINT

When drawing a damaged robot, start with a seam where two pieces meet. Here, the metal is not quite as strong, so it will fall apart faster.

INITIAL BREAK

After repeated stress, the internal structure (a metal "bone") snaps off. Without the needed support, the wires stretch out and drag downward.

TOTAL DESTRUCTION

Lacking the support of the "bone," the bottom falls off completely. The weight continues to drag at the wires until they break, leaving only frayed ends behind.

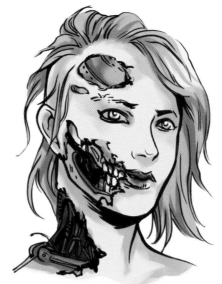

SYNTHETIC SKIN DAMAGE

If a robot's synthetic skin is peeled back to reveal the mechanical parts underneath, you'll draw the ripped edges in a similar way to torn fabric. Most of the lessons in chapter 2 on damaged clothing can be used to great effect on a worn-down robot.

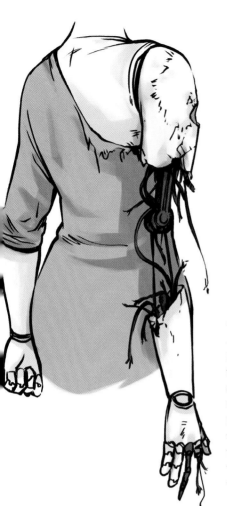

LARGE-SCALE DESTRUCTION

Now that you've practiced the basics, try it on a larger scale. In this example, most of the arm is missing, and the damaged wires dangle uselessly. A few wires are still attached, though, and are pulled taut by the lower arm.

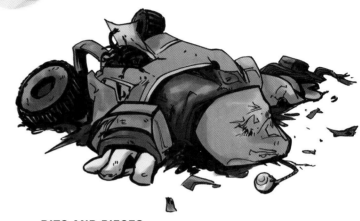

BITS AND PIECES

Sometimes there's nothing left to repair. To draw a robot that's bound for the scrap heap, hint at what it used to be: a hand, two wheels and a damaged head. When taken together, the viewer sees it as the remnants of a robot instead of a pile of unrelated parts.

RECHARGING

Not every character will let their robot fall apart. Some take good care of them, provide regular maintenance and allow plenty of downtime for plugging into their docks to recharge.

5 *The Final Frontier*

It's out there, far beyond the planet Earth: the vast and awe-inspiring reaches of space. In science fiction, travel among the stars, human colonies on distant planets, and even alien creatures are not only possible, but commonplace. If your characters are gearing up to catch a rocketship to the other side of the universe, take some time to explore the unique artistic challenges presented by life among the stars.

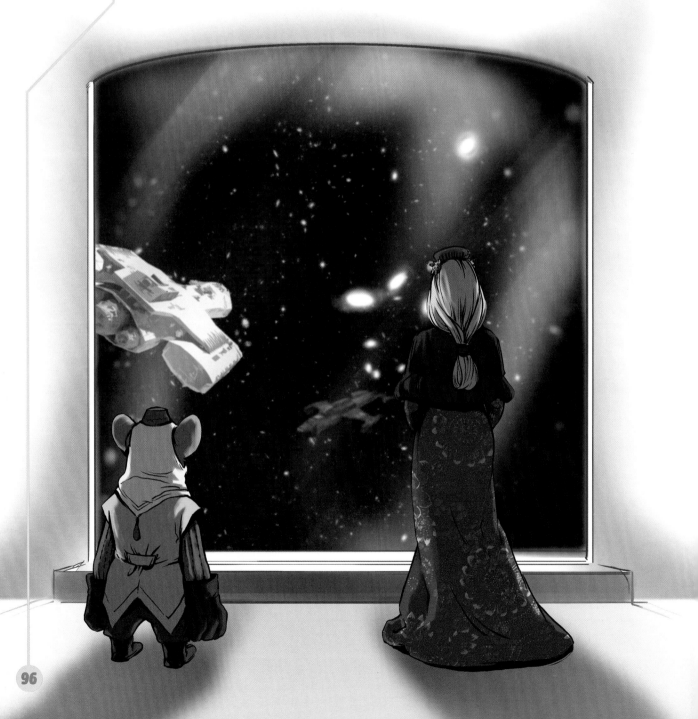

Aliens

Far-off worlds often come with inhabitants, and those inhabitants, by virtue of being something completely outside our realm of experience, offer a huge opportunity for unique designs. Let's be real—a lot of the aliens that influence science fiction are humanoid just because it's cheaper to put some face prosthetics and makeup onto human actors. With art, you have a lot more freedom, and designing alien creatures is one area that lets you really flex your creative muscles.

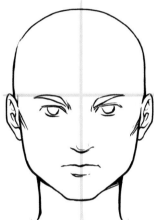

A HUMAN FACE
If you're going to draw a humanoid alien, start with the human face as a guideline.

BUILD UP YOUR FACE
Once your guideline is in place, tweak the features or add new parts. You can resize eyes, noses and mouths, or remove them altogether.

ANIMAL INFLUENCE
Try taking inspiration from Earth creatures that aren't human. Add some animal or insect features. You'll notice that the more you put in, the more your design starts to branch away from humanity.

Alien Anatomy

In a lot of sci-fi media, alien bodies are humanoid and bipedal because the actors playing them are humans. It's easier to dress a person in a costume than to create a creature from scratch for a movie. Lucky you, drawing gives you a lot more leeway with your design.

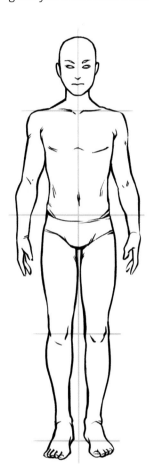

A HUMAN BODY

When designing an alien's anatomy, start by sketching a regular human with average proportions for comparison.

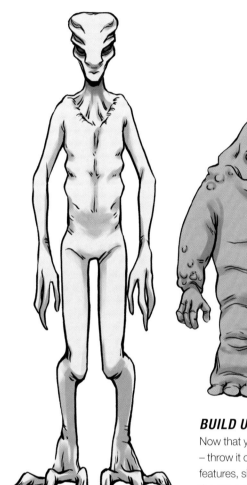

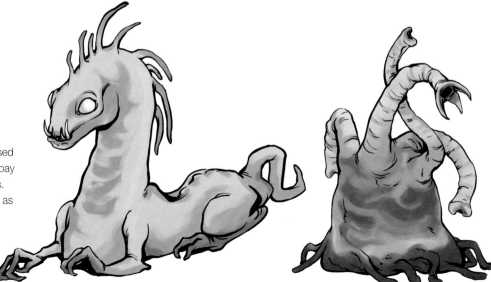

BUILD UP YOUR BODY

Now that you have standard human anatomy – throw it out the window. Edit the proportions, features, sizes and weights. The more you change, the more alien the creature will seem.

NON-HUMANOID ALIENS

The plus side to drawing aliens as opposed to filming them is that you don't have to pay for special effects or elaborate costumes. Your aliens can look as out-of-this-world as you want them to.

Alien Worlds

If you're having trouble coming up with ideas for alien designs, start by creating the world they come from instead. Animals evolve and adapt to their habitat; why not make it the same for creatures from another planet? Think of an idea for a world first, then see where your imagination takes you.

Red Swamp

This world is humid and almost tropical. It's covered in lots of flora, swamp, and jungle.

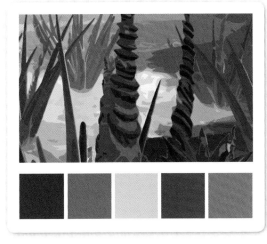

ANIMAL LIFE

Aliens on this planet might use the surroundings to camouflage themselves. They look like the flowers or trees that grow in swampy ground.

HUMANOID LIFE

The dominant species are lithe, with froglike appendages that make it easy for them to get around in the swamp. It's a hot, wet environment, so their clothes are light and probably waterproof or quick to dry.

Gas Giant

This world has no land or even water. It's completely made of gas, which means that all its inhabitants will need to be able to travel through the air.

HUMANOID LIFE

Some aliens on this planet are humanoid, with changes to enable them to glide through the air. Gone are the useless feet and legs, replaced instead with flaps that enable propulsion like a manta ray.

ANIMAL LIFE

Try creating alien forms that are similar to animal life on Earth. The whale already has a mechanism to swim through liquid—with a few tweaks, you might be able to make it take to the sky instead.

Ice World

This planet is harsh and unforgiving. It has a lot of snow, ice and rocks, and not much else.

HUMANOID LIFE

The aliens on this planet are thick and strong, built to withstand the cold. Even though they only have furs from the native animals, they can survive in the extreme weather.

ANIMAL LIFE

Like Earth's wooly mammoths, the animals on this world will need blubber and thick, protective fur to keep them warm.

Dark Gem World

This planet is far from any stars, so it catches little light. What illumination there is reflects on the crystals formed on the planet's surface.

HUMANOID LIFE

On a world like this one, large eyes will help the inhabitants catch whatever light is available, and large ears will keep the aliens from being quite so reliant on vision. If the inhabitants are intelligent, they might design clothing or objects that increase the available light.

ANIMAL LIFE

In a world where vision makes little difference, most creatures will have no pigment. A lot of the fauna are blind, as eyesight does little to aid survival. Natural camouflage might be based on touch as much as sight.

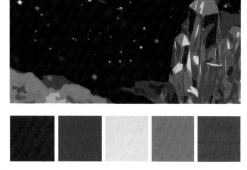

Space Exploration

Way out in the darkest reaches of the farthest galaxy, intrepid space explorers press the limits of the known in order to discover everything outer space has to offer. Despite the dangers, their mission for knowledge pushes them forward—and with a top-of-the-line spaceship, dazzling technology and the brightest minds in all the known worlds, their voyage will take them to the unmapped ends of the universe.

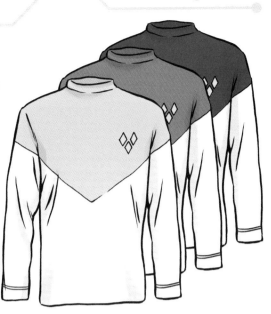

UNIFORM PALETTE

This crew is well organized and well put-together, so they wear uniforms when they're on duty. Select a group of colors to use as a base for their garments, and stick with it. Consider giving each shade in the palette significance, such as rank, department or job specialty.

LOGO PALETTE

Design a symbol for your crew or the organization they represent. You'll need a palette for this, too, but make sure it shows up against the colors you picked for the uniforms.

UNIFORM SHIRTS

Start with the most basic design: a simple shirt that can be combined with other garments to make a more elaborate uniform.

RANK INSIGNIA

Is your organization military? You'll probably want to give some thought to how they display rank. To keep everything visually connected, try taking design elements from your logo and using that for the ranking system. In this example, the more diamonds and lines, the higher the rank.

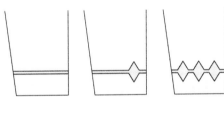

FORMAL UNIFORM

Your crew will probably need a high-class uniform for fancy occasions or diplomatic meetings. Try using the uniform color on the epaulet to make the V design on the jacket.

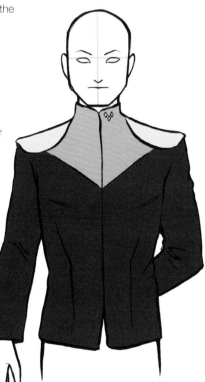

OTHER UNIFORM POSSIBILITIES

After you've got a basic look for your shirts, branch out. Base the new designs on the aesthetic you created, but alter the type of garment or swap the color locations.

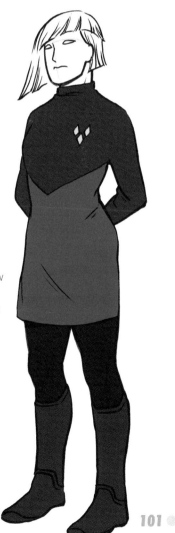

Variety in Uniforms

When you design a cast of characters, it's important for the viewer to be able to tell them apart visually, especially when everyone is wearing the same uniform. Diversity helps with this, so give your characters different heights, weights, genders, skin tones or even planets of origin. You can also vary the uniforms a little from character to character to help set them apart. Small changes keep the cohesive look but also allow the viewer to distinguish between characters at a glance.

FULL FLEET

- **Crewman (A):** The crew's uniform, originally designed by and for humans, has to be altered to accommodate different alien body types. Even with the changes, carry through design elements like the predominant color, V design and rank insignia.

- **Engineer/Mechanic (B):** Uniforms can also change depending on the wearer's job. The ship's mechanic is hands-on with the inner workings, so he wears coveralls to keep clean when the going gets greasy.

- **Android (C):** A random layer of fabric doesn't help a mechanical creature in any way, so instead of clothes that have to be washed and maintained, its uniform is just painted on.

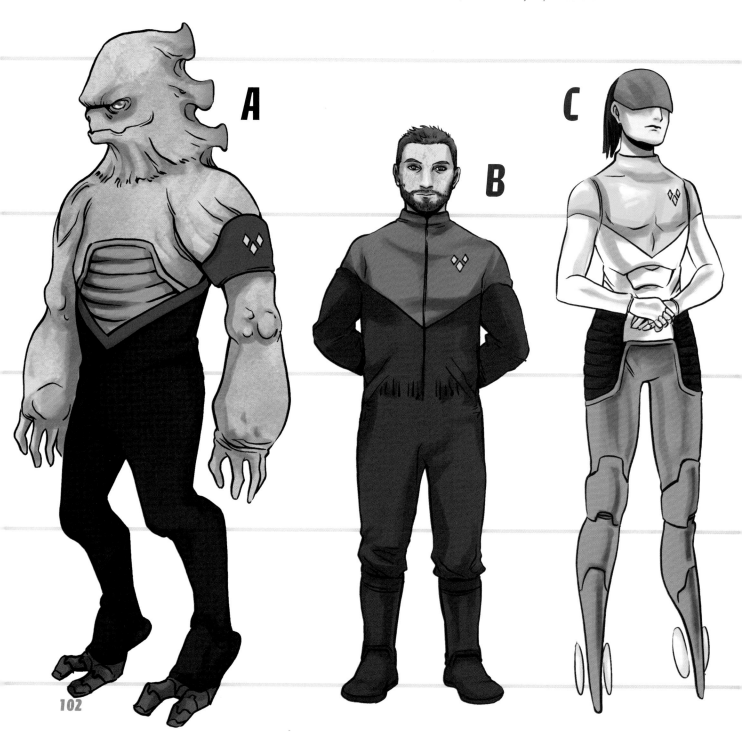

A

B

C

- **First Officer (D):** The first officer wears the standard style of uniform with no alterations. Make sure to add the rank insignia you designed earlier; in this example, his rank is displayed by the lines and diamonds on the cuffs of his sleeves.

- **Pilot (E):** Just like in certain modern militaries, some accommodations can be made for crew members' religions. The pilot stays on board most of the time, so she can wear the hijab and dress without difficulty. Like her crewmates, she has different versions of her uniform for different occasions and hijabs in the appropriate colors to match.

- **Chief of Security (F):** The chief of security has a uniform that reflects her need for maximum mobility and extra protection. Her clothes fit closely to promote ease of movement, the vest serves as light body armor and her knees are padded. She wears a holster and blaster to show her rank and be ready in case of action.

- **Intelligence Officer (G):** Sometimes alien creatures are so different from humans that they require major changes to the uniform. This tiny alien flies around in its own personal ship, for ease of movement and to keep safe from the feet of larger beings. In cases like this, you might need to think outside the box; for example, try applying the uniform design elements to the tiny vessel instead of the alien itself.

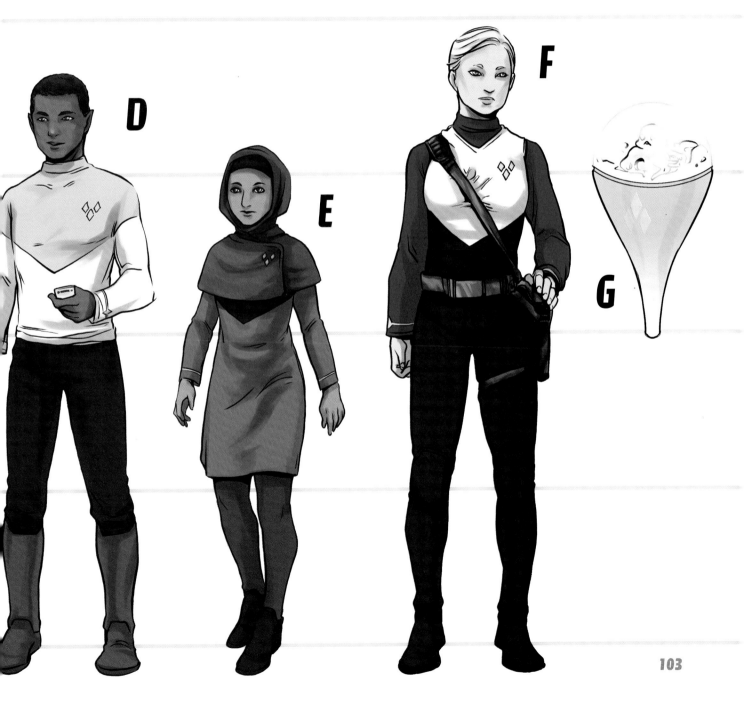

Uniforms for All Occasions

Your uniforms don't have to stop at the basic. Members of your crew might need different types of garments depending on the mission, but the design elements should maintain a cohesive look. The insignia you chose should always be present, and so should the appropriate color from your uniform palette. In these examples, the V and diamond motifs are recurring themes.

LAB COAT

The search for knowledge means science, and science means something to wear in the lab.

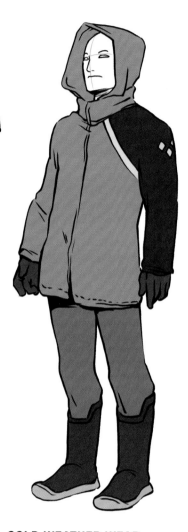

CASUAL OR WORKOUT TANK

During downtime or PT, crew members need something not quite so restrictive.

COLD WEATHER WEAR

If your characters know in advance that they'll be visiting a planet with hostile weather, they should dress accordingly.

SPACE SUIT

Your crew will need appropriate gear for ship repairs or emergencies that require a spacewalk.

THE STARSHIP CREW

In galaxies far beyond our own, there sails a starship packed with cutting-edge technology and a group of professionals who are experts in their fields. The Starship Crew doesn't all hail from Earth; they're certainly not all human. They span a huge variety of personality types and appearances, but their unending search for knowledge, steadfast commitment to the pursuit of justice and dedication to their work and to each other bind them together more closely than the ties of any country.

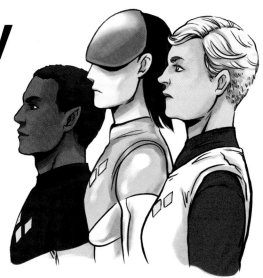

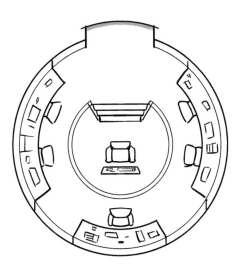

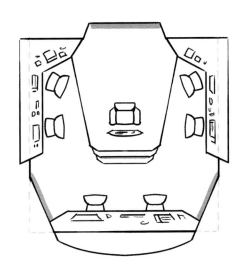

1 SKETCH SOME FLOOR PLANS

The bridge is where a lot of the action and decision making takes place, so your crew will spend a lot of time there. You'll make your life easier later on if you have a layout design in advance. Start with a floor plan. First, decide what you need: seats for the captain and first officer, controls for the pilot and co-pilot in front and seats facing various monitors and panels for the other crew members. Mark the doorways in a different color.

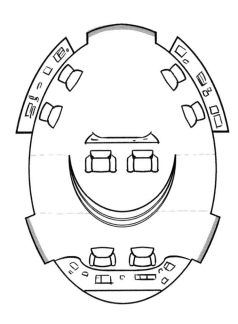

2 SELECT A DESIGN

Take a look at your sketches and decide which one you like best. The size and configuration are all up to you; the layout doesn't even have to be symmetrical, although symmetry does look more orderly. For this example, we'll use an oval-shaped bridge.

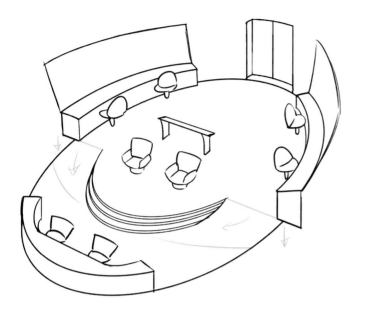

3 MAKE IT 3-D

After deciding on the floor plan, draw a three-dimensional concept of the bridge. If you're drawing a graphic novel, you can use this image as a reference to help visualize the possible angles to use in various scenes. This image should start to show things the floor plan did not, such as the change in elevation on the higher platform leading down to the pilot seats.

4 SKETCH THE SCENE

Now that your bridge is ready, sketch the scene you want to set there. For this example, we'll show several characters and use an angle that's a bit off-center. The perspective doesn't have to be perfect yet; once you have the concept, you can work it out in further detail.

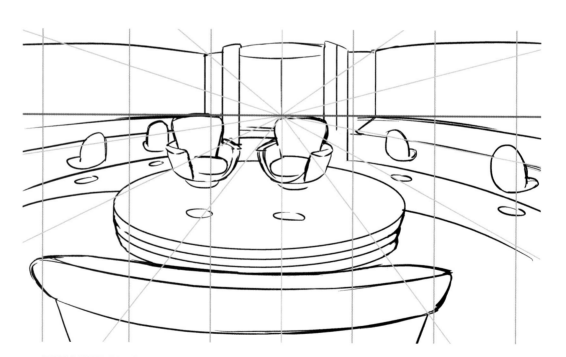

5 TRY SOME PERSPECTIVE

Next, you're ready to draw the environment and make sure your perspective is in place. Set your vanishing point to a spot in the middle of the image at the line where the elevator doors close. Draw a red horizon line that follows the top part of the desks, then add a set of blue lines that radiate out to create a guide for the ship's interior. Vertical lines in purple will help make sure the vertical lines in your ship are straight. Be sure to curve the outline of the ship itself because the room is oval.

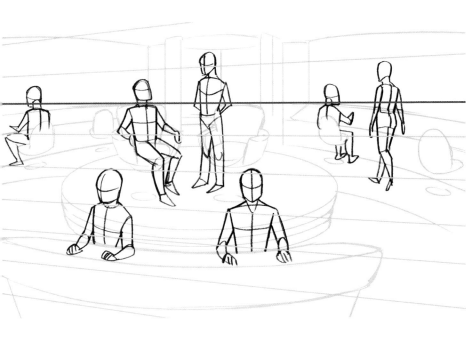

6 FINE-TUNE THE PERSPECTIVE

Add another vanishing point to the far left of the image, off-panel, then draw the green lines that radiate out from that point. Next, start to sketch your characters. They need to interact with the environment, but make sure they aren't displacing items that can't move. All of the characters should look like they're on the same plane to keep things in proper scale. The red horizon line will pass through the necks of the seated characters and the torsos of the standing characters. One of the green lines also lines up with the heads of the pilots. A lot of measuring and fine-tuning is needed to make sure the perspective looks right, but it'll pay off in the end, and you won't have to do a lot of corrections.

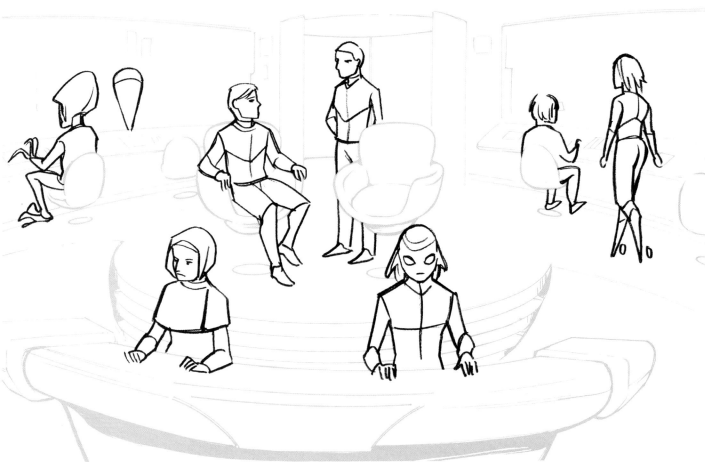

7 ADD DETAIL

After getting all the measuring done and finalizing crew locations, it's time for the fun stuff. Start adding more detail to your crew members and the bridge. If you want to keep the ship clean and streamlined, don't add too much; the plain lines will go a long way toward giving it a minimalist, high-tech look.

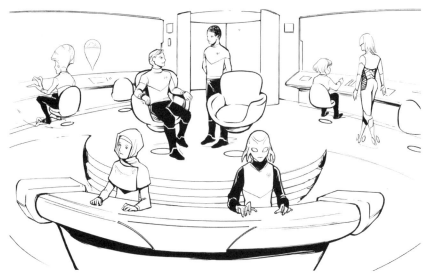

8 INK IT

Start adding your ink, but keep it simple with just a few shadows under the console and stairs. The sleek and solid look of the ship should contrast with the crew members, who have natural movement and clothes with asymmetric creases and shadows. Leave the screens and panels blank; you can fill those in later when you color.

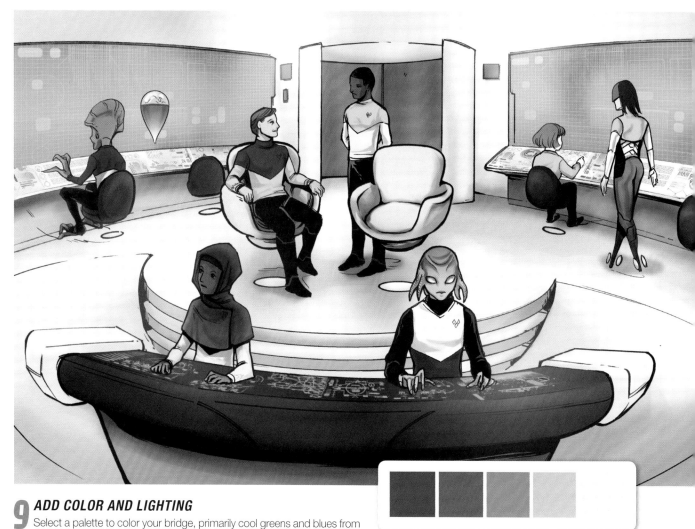

9 ADD COLOR AND LIGHTING

Select a palette to color your bridge, primarily cool greens and blues from the bridge materials and view screens. Your characters will add an extra splash of color.

The ship interior is actually rather small, so keep it bright and well-lit to make sure the space doesn't look cramped. Try tinting the lighting blue so it looks a little bit cold and distant, like outer space.

Inhuman Shapes

Creating characters by sketching silhouettes is a quick, easy way to get some variety in your designs, and it works doubly well for alien creatures. To create unique looks, sometimes it's easier to start out with shapes and not let the details bog you down. This technique is especially helpful for populating a crowd with many types of creatures.

HUMAN SHAPE
Before you start creating alien forms, begin by sketching a basic human silhouette for comparison.

ALIEN SHAPES
Next, create some outlines that look anything but human. Play around and scribble simple shapes. You don't have to be too careful about detail yet.

FLESH OUT THE REST
Part of the fun with silhouette shapes is that you can translate them into fully clothed figures, as opposed to just the body. Taking simple outlines as inspiration, try creating detailed clothed figures.

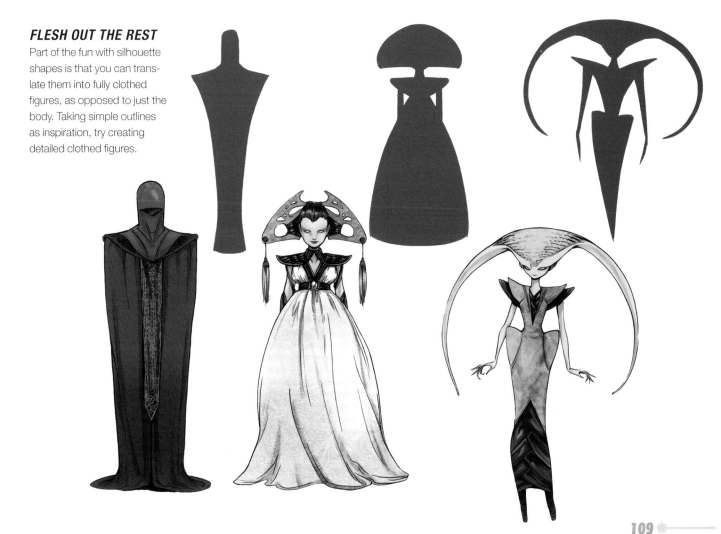

Space Opera

In the distant reaches of space, amidst planets populated with fantastical beings and breathtaking vistas, a battle is brewing. It's a battle between good and evil, told with high adventure, grand clashes of opposing forces and maybe even a hint of romance. The stakes are high, the weaponry puts the fiction in science fiction, and at the end of the day, the heroes will stand victorious.

SPACE OPERA CLOTHES

When you're designing clothes for the sub-genre of science fiction known as a space opera, aim for the showy and elaborate. This particular type of tale is usually big and bold, both in storytelling and in visuals, so don't shy away from getting too fancy.

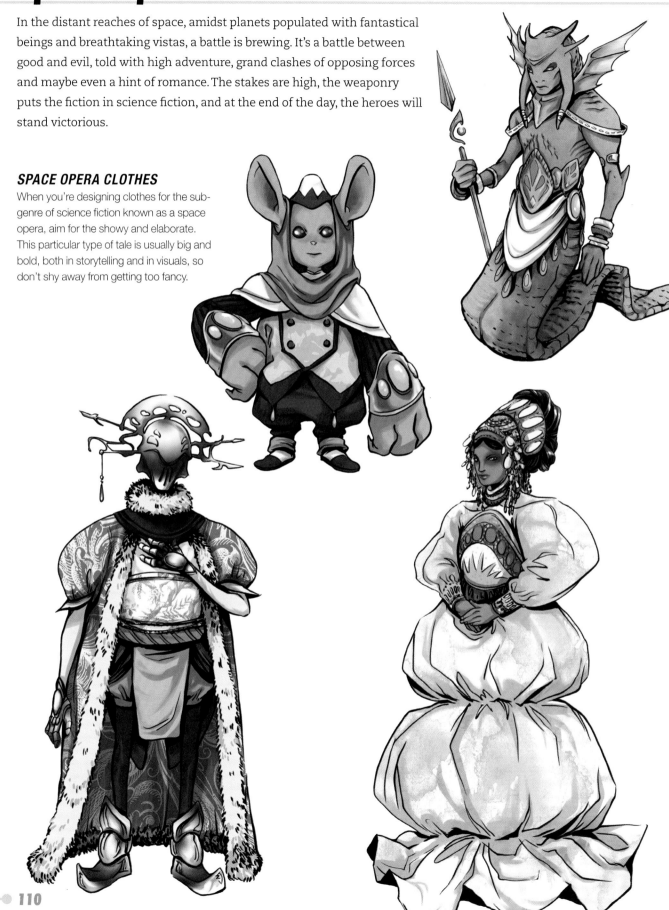

Glamour From Beyond the Stars

To get a handle on drawing elaborate clothes for your space opera, focus on just one part of the costume and make that particular part more ornamental. Try an over-the-top hair style or a fancy hat or a patterned cape. Remember, these characters are living in space, so feel free to design an alien to go with your new look.

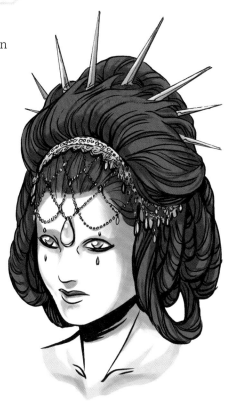

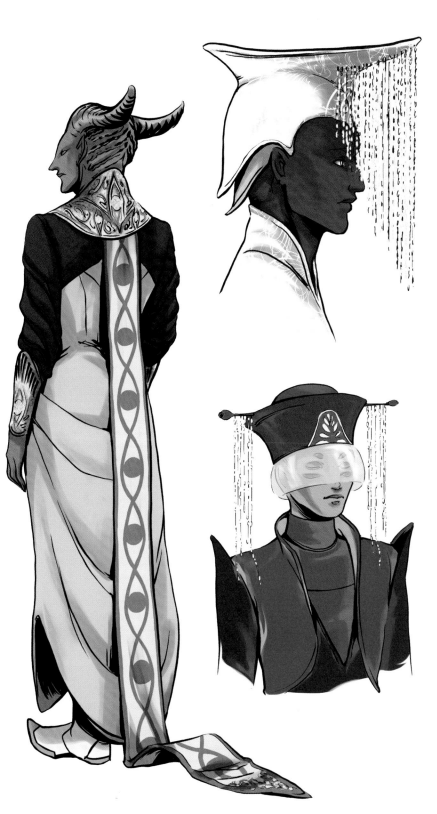

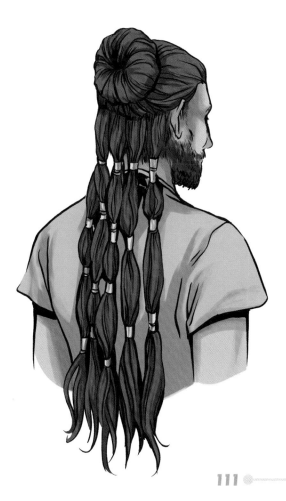

ADDING A REFLECTIVE SHINE

Jewelry and trinkets are tricky to draw because without the proper sheen on the metal, they look flat and texture-less. To practice, try your hand at adding a metallic gleam to a simple shape.

1 PICK YOUR COLORS
First, select three colors—a midtone, a shadow and a highlight. With highly reflective surfaces, the highlight will almost be white, while the shadow is extremely dark. The sharp contrast between the two captures the feel of a reflective surface.

2 SELECT A LIGHT SOURCE
Decide where the light in your picture is coming from. In this example, the light comes from the right of the sphere, so the highlight is on the right and the shadow tone is on the left.

3 FILL IT IN
After setting in your three main colors, fill in the shift in hues between them. The transition between the different colors mimics the play of light on the metal.

4 MIND THE EDGES
The darkest shades on the sphere won't go all the way to the edge. Since the sphere reflects all of the ambient light in addition to the light source, make sure to keep a lighter golden hue at the outer rim, even on the side in shadow.

5 REFLECT ANOTHER OBJECT
Objects with a high metallic sheen can also reflect colors that are in close proximity. If your sphere is near another object, add a hint of the same color in the direction of the object.

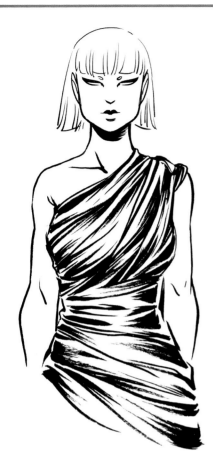

BLACK AND WHITE

You can suggest a metallic shine even with black and white ink. Try something similar to this dress. The dips and valleys offer a lot of opportunity for deep shadow, while the ridges have very bright highlights.

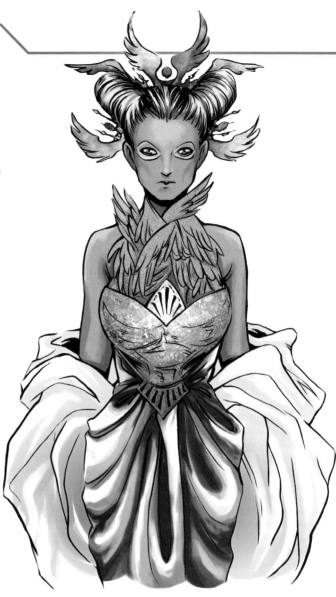

FIFTY SHADES OF GOLD

Not all shiny objects are created equal; different surfaces create different levels of sheen. For example, here the feathers are metallic but textured, the top is a worn-looking antique gold and the skirt has a high shine.

ALL THE COLORS OF THE RAINBOW

You don't have to limit your metallic hues to gold and silver. The same basic technique will allow you to give any color a metallic look.

ADDING SPARKLE

Another way to make an elaborate outfit even more eye-catching is to add some sparkle. Follow these steps to make your character's clothing twinkle like the stars.

1 PICK YOUR COLORS
Before you start, select three colors. You'll want a mid-tone, a highlight and a shadow that all stem from the same hue.

2 LAY IN DARKER TONES
The mid-tone area is where the light shines. Put that in first, then use the darker tone for shadow. Use dots to represent sequins or glimmering beads—anything that goes on fabric to make it shine.

3 ADD THE HIGHLIGHT
Start adding the highlight color on the area where the light reflects off the material. If you overlap the colors, it creates an effect that seems random.

4 MAKE IT SHINE
Add a smattering of smaller circles to act like light glinting off the material and a few tiny sparkles in white. The circles in this sample are like very large sequins.

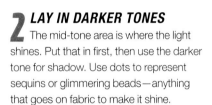

5 PRACTICE THE TECHNIQUE
Now that you know how to add some glitter to clothes, practice working it into a few of your costume designs.

Flowing Fabric

Space operas abound with wise, mysterious types, and be they old or young, man or woman, their role is to set the hero on a path to knowledge and victory. These prophets and teachers tend toward obscuring clothing to promote a sense of enigma, so let's take a look at how to draw flowing fabric. If you're interested in more tips, check out *Shojo Fashion Manga Art School*.

NO WIND
The best way to practice drawing flowing fabric is to start with a single piece of cloth. No wind is blowing, so it hangs limp.

A SLIGHT WIND
Fabric moves when outside weather forces act upon it. When the movement is mild, the bottom line of the fabric pulls up slightly in the middle.

THE WIND PICKS UP
If the wind gets stronger, the fabric captures the wind in the middle like a parachute, forming a U shape.

BLOWN BACK
As the wind begins to blow the fabric back, the U shape gets repeated, and the edges of the cloth look like a wavy line.

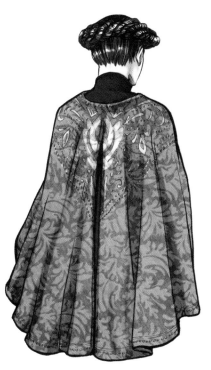 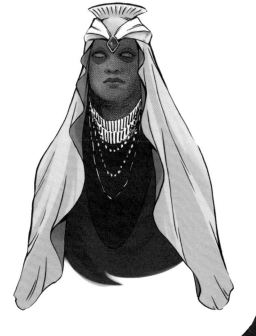

PRACTICE EXCESS FABRIC
Try drawing your characters in an outfit that includes a lot of extra fabric. If the excess isn't tailored close to the body, there will be a draping effect. To observe this effect in life, place a pillowcase over your arm and watch the way the fabric falls.

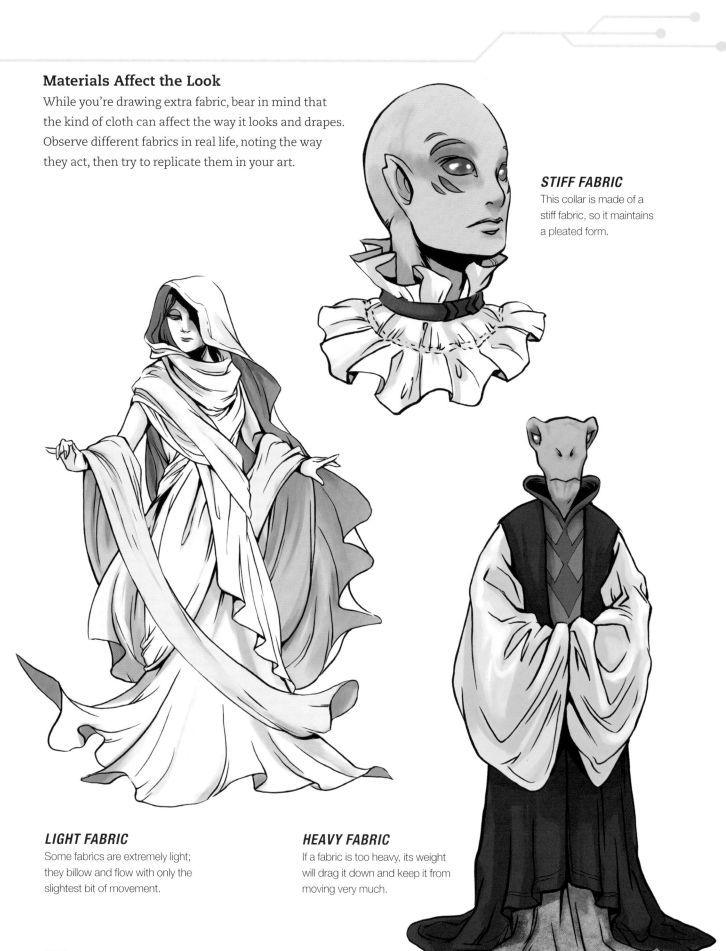

Materials Affect the Look

While you're drawing extra fabric, bear in mind that the kind of cloth can affect the way it looks and drapes. Observe different fabrics in real life, noting the way they act, then try to replicate them in your art.

STIFF FABRIC
This collar is made of a stiff fabric, so it maintains a pleated form.

LIGHT FABRIC
Some fabrics are extremely light; they billow and flow with only the slightest bit of movement.

HEAVY FABRIC
If a fabric is too heavy, its weight will drag it down and keep it from moving very much.

The Good Guys

Most space operas feature an epic battle, and on one side of it stand the brave men and women struggling to save the universe as they know it. Consider your setting while designing the look for your heroes, but here are a few tips that will help you get started.

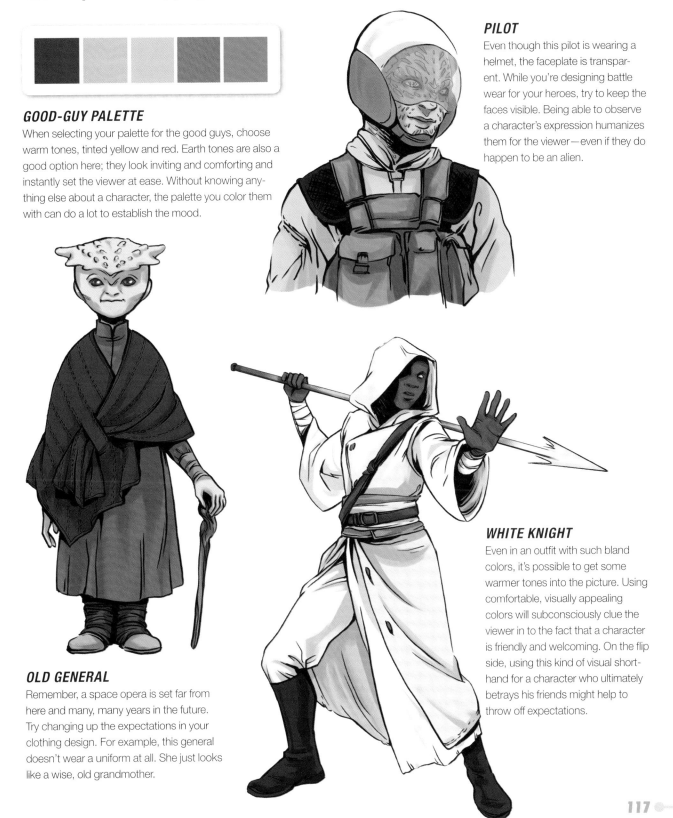

GOOD-GUY PALETTE

When selecting your palette for the good guys, choose warm tones, tinted yellow and red. Earth tones are also a good option here; they look inviting and comforting and instantly set the viewer at ease. Without knowing anything else about a character, the palette you color them with can do a lot to establish the mood.

PILOT

Even though this pilot is wearing a helmet, the faceplate is transparent. While you're designing battle wear for your heroes, try to keep the faces visible. Being able to observe a character's expression humanizes them for the viewer—even if they do happen to be an alien.

OLD GENERAL

Remember, a space opera is set far from here and many, many years in the future. Try changing up the expectations in your clothing design. For example, this general doesn't wear a uniform at all. She just looks like a wise, old grandmother.

WHITE KNIGHT

Even in an outfit with such bland colors, it's possible to get some warmer tones into the picture. Using comfortable, visually appealing colors will subconsciously clue the viewer in to the fact that a character is friendly and welcoming. On the flip side, using this kind of visual shorthand for a character who ultimately betrays his friends might help to throw off expectations.

ALL WALKS OF LIFE

In a battle of the size and scale seen in most space operas, all hands are welcomed to the cause. Showing variety in your character designs will go a long way toward telling the wide-spread appeal of the fight, all without a word.

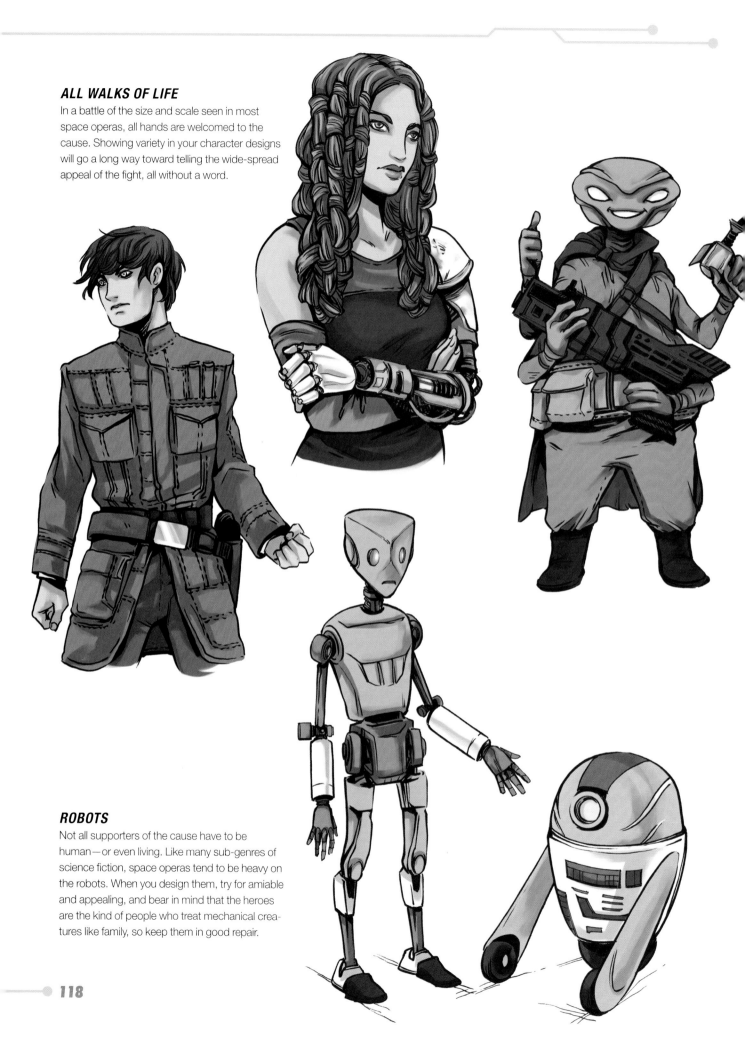

ROBOTS

Not all supporters of the cause have to be human—or even living. Like many sub-genres of science fiction, space operas tend to be heavy on the robots. When you design them, try for amiable and appealing, and bear in mind that the heroes are the kind of people who treat mechanical creatures like family, so keep them in good repair.

THE CHOSEN ONE

The Chosen One grew up on some backwater planet where breaking the soil was a rough way to make a living. She did it anyway, and the hard work, early mornings and calloused hands made an honest woman of her. She's optimistic and practical, handy with a wrench and takes whatever the universe throws at her without batting an eye. Good thing she's so open-minded—she just so happens to be the Chosen One proclaimed by the prophecy, harboring a mysterious power within.

1 STRIKE A POSE

For the Chosen One, select an active pose. As the red line bends at her torso, it shows that she's bent forward, stomach compressed as she brings her leg up to get a foot on top of the rock. This position showcases that our hero is both athletic and curious—something has intrigued her enough to clamber over this outcropping, and she's not going to stop until she knows what's on the other side.

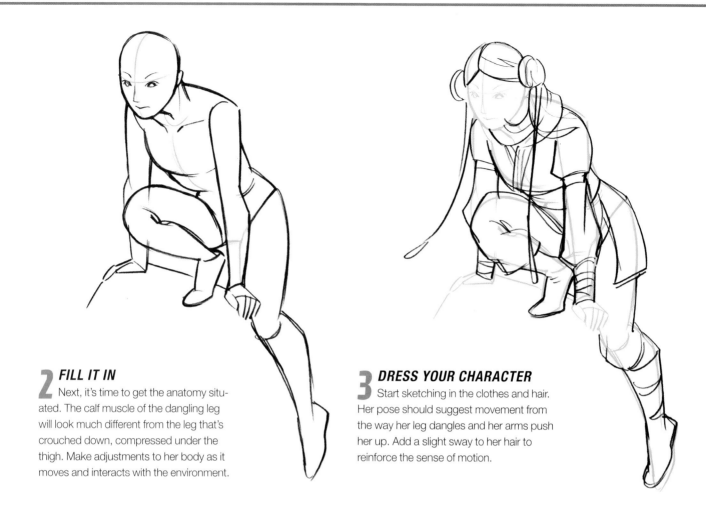

2 FILL IT IN

Next, it's time to get the anatomy situated. The calf muscle of the dangling leg will look much different from the leg that's crouched down, compressed under the thigh. Make adjustments to her body as it moves and interacts with the environment.

3 DRESS YOUR CHARACTER

Start sketching in the clothes and hair. Her pose should suggest movement from the way her leg dangles and her arms push her up. Add a slight sway to her hair to reinforce the sense of motion.

4 ADD DETAIL

Clean up your sketch and add more detail to her hair and clothes. Now's the time to decide on an expression for her. She is wide-eyed and curious, which works well to reinforce her personality.

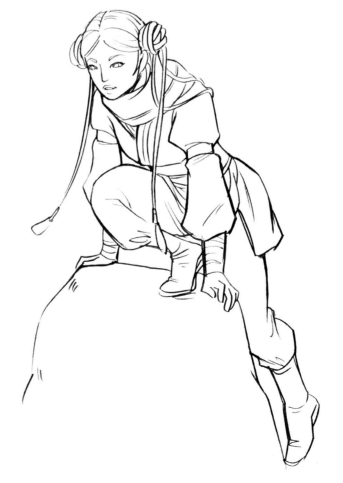

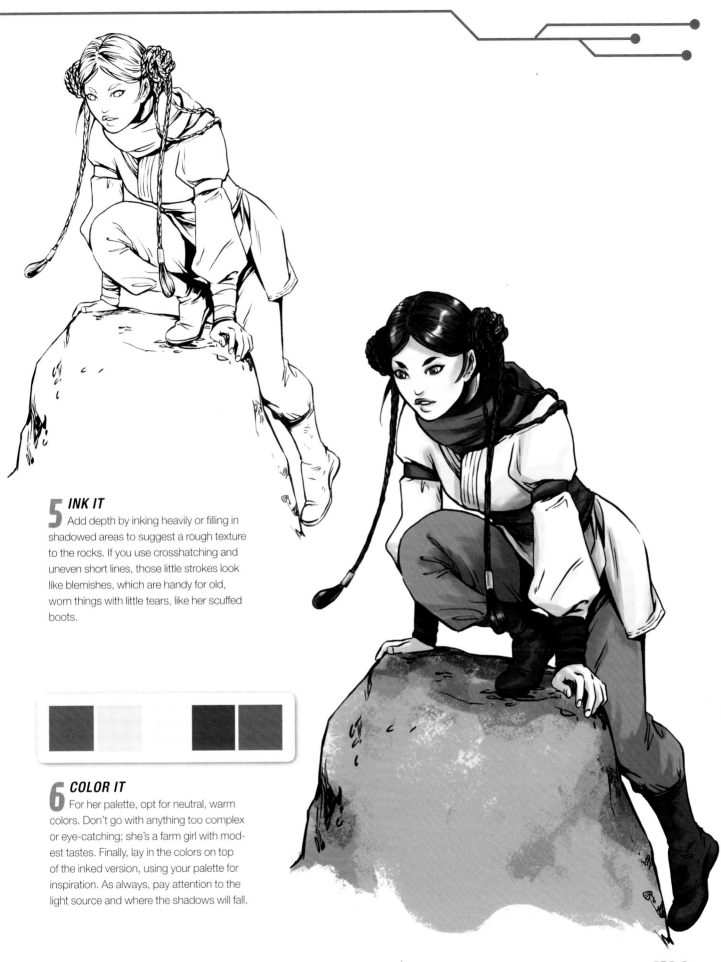

5 INK IT

Add depth by inking heavily or filling in shadowed areas to suggest a rough texture to the rocks. If you use crosshatching and uneven short lines, those little strokes look like blemishes, which are handy for old, worn things with little tears, like her scuffed boots.

6 COLOR IT

For her palette, opt for neutral, warm colors. Don't go with anything too complex or eye-catching; she's a farm girl with modest tastes. Finally, lay in the colors on top of the inked version, using your palette for inspiration. As always, pay attention to the light source and where the shadows will fall.

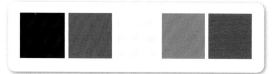

The Bad Guys

In every legendary clash of good versus evil, the heroes need opposition to make their struggle a battle to remember. While you're crafting the bad guys for your space opera, keep in mind that the threat should have some sense of consequence, but stay away from cartoon villains. Make sure your bad guys have a well-thought-out design and believable motivations, just like the heroes.

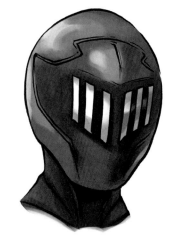

COLOR PALETTE OF EVIL

To set the tone for your bad guys, select a palette based heavily in black and cool grays. Lighter tones are also OK, but tinge them with blues, greens and purples. Opt for cool colors, as opposed to the warm and inviting tones for the good-guy palette. Red is the exception—feel free to throw some in for menace. It's the color of blood and anger, and it carries a lot of emotional associations for the viewer.

SOLDIER

When you're designing a head piece for a villainous character, opt for a helmet that hides the face. Keeping a character's expression out of view adds a sense of detachment and anonymity.

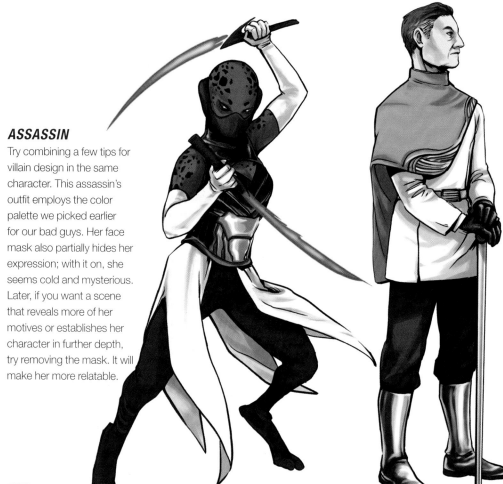

ASSASSIN

Try combining a few tips for villain design in the same character. This assassin's outfit employs the color palette we picked earlier for our bad guys. Her face mask also partially hides her expression; with it on, she seems cold and mysterious. Later, if you want a scene that reveals more of her motives or establishes her character in further depth, try removing the mask. It will make her more relatable.

OLD GENERAL

Use a character's outfit to say something about him as a person. Without knowing anything about this man, we can tell that he's neat, well-groomed and somewhat intimidating. He wears a uniform and keeps a military bearing, and his body language makes him seem hard and unapproachable.

One Color, Many Looks

When your palette consists mostly of black, it can sometimes look flat and plain. Use texture to add some interest, and experiment with different ways to set characters' outfits apart from one another.

LEATHER
Leather can be shiny, but it's not as over-the-top bright as metal or beads. Go heavy and dark on the shadows, and when you add highlights, they should be almost white. You can work in some extra design elements by picking out the seams.

COTTON
Cotton isn't very glossy, so use less contrast when you shade it. Don't make the highlights as bright as you would for leather.

WOOL
With a wool shirt, make sure the texture of the fabric is visible at certain points on the garment to emphasize that the cloth isn't smooth. You'll end up with a shirt that looks warmer and thicker as a result.

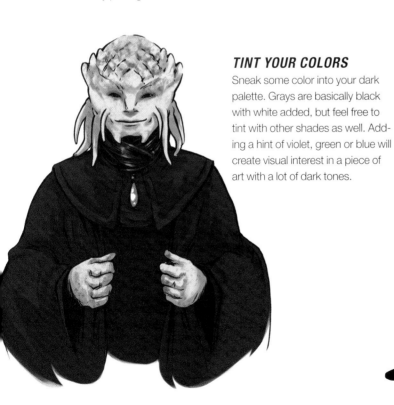

TINT YOUR COLORS
Sneak some color into your dark palette. Grays are basically black with white added, but feel free to tint with other shades as well. Adding a hint of violet, green or blue will create visual interest in a piece of art with a lot of dark tones.

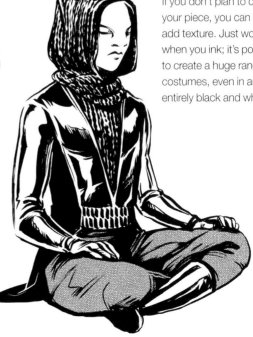

TEXTURE WITH INK
If you don't plan to color your piece, you can still add texture. Just work it in when you ink; it's possible to create a huge range of costumes, even in art that's entirely black and white.

THE MAN IN BLACK

The Man in Black is shrouded in mystery, and he serves as a counterpoint to the Chosen One in almost every way. Where she's guileless and straightforward, he deals in manipulation and lies. He's the shadowy face of a powerful and unscrupulous organization on the far edges of space, but what makes him most dangerous is that he truly believes his path will lead to a better world order. He, too, has a power lurking deep within him, but he recognizes it for what it is, and it's not the power of light.

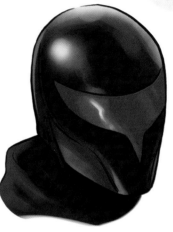

1 STRIKE A POSE

For the Man in Black, select a pose that keeps him bent and low to the ground. Set the tone for his personality; think of a giant cat stalking its prey, ready to strike with its claws.

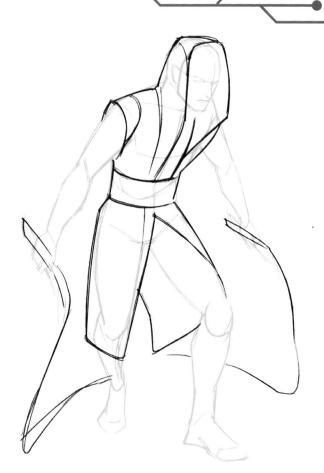

2 FILL IT IN
Next, fix the anatomy and edit before continuing. Change the position of his foot and leg slightly to give him a slow forward motion. In the original sketch, he seemed to be preparing for a quicker lunge.

3 DRESS YOUR CHARACTER
Start adding in rough ideas for the costume. His face is visible here even though he'll wear a mask in other scenes. It's OK to plot out clothing that doesn't appear yet. Just like people, characters don't have to wear exactly the same outfit every day.

4 ADD DETAIL
Create a bit of excitement in the pose by swirling his robes around. Dramatic villain entrances sometimes deserve a bit of dramatic wind action.

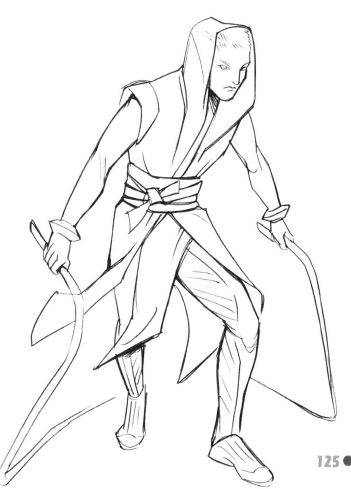

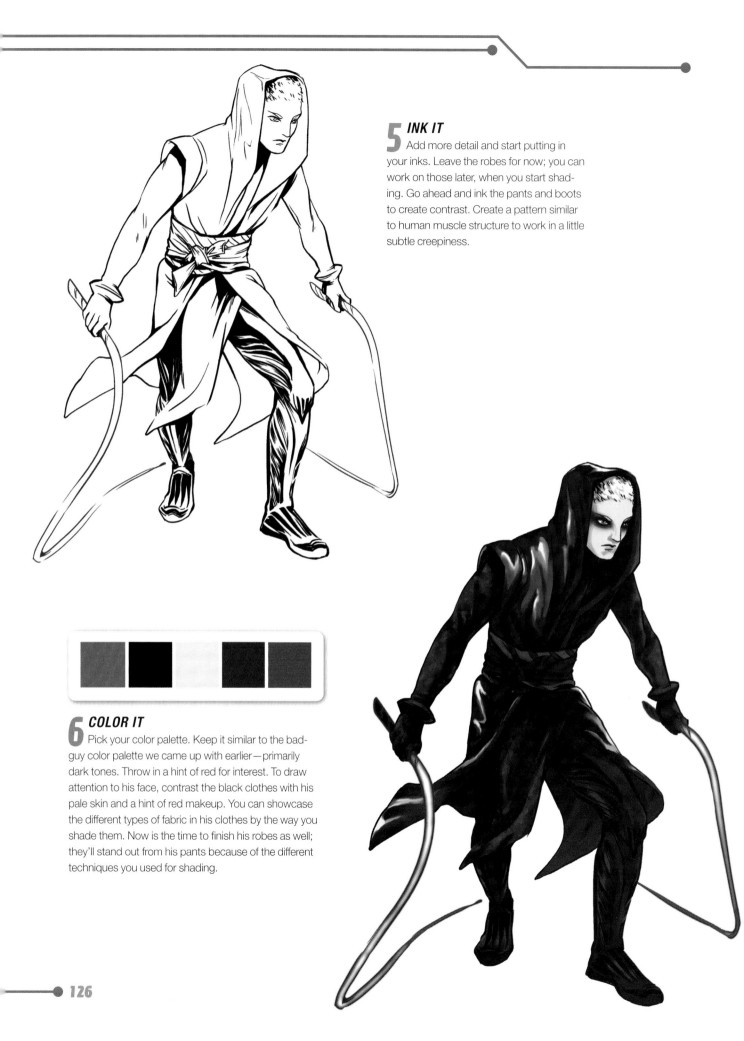

5 INK IT

Add more detail and start putting in your inks. Leave the robes for now; you can work on those later, when you start shading. Go ahead and ink the pants and boots to create contrast. Create a pattern similar to human muscle structure to work in a little subtle creepiness.

6 COLOR IT

Pick your color palette. Keep it similar to the bad-guy color palette we came up with earlier—primarily dark tones. Throw in a hint of red for interest. To draw attention to his face, contrast the black clothes with his pale skin and a hint of red makeup. You can showcase the different types of fabric in his clothes by the way you shade them. Now is the time to finish his robes as well; they'll stand out from his pants because of the different techniques you used for shading.

THE DUELISTS

The duelists come together as a symbol of opposition: light against darkness, good against evil, polar opposites trapped in a battle as old as time itself. At the climax of their respective stories, the Chosen One and the Man in Black fight for what they each believe to be right, bringing to bear the mysterious power that lies within them both.

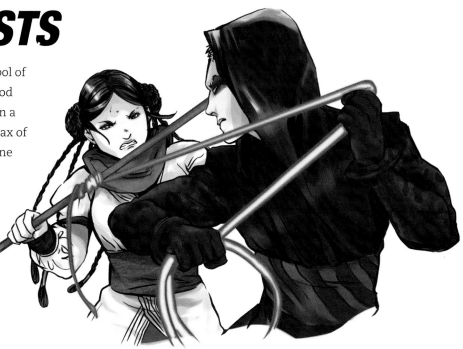

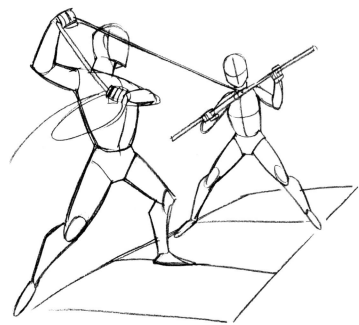

1 SKETCH SOME POSES

Think about different ways to frame the scene. In this case, let's go ahead and frame it at a wider angle to showcase some cool fight moves. Sketch out a few poses that you think might look good; go for big, bold and active.

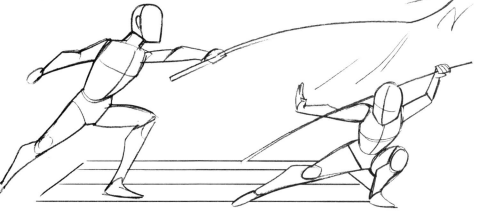

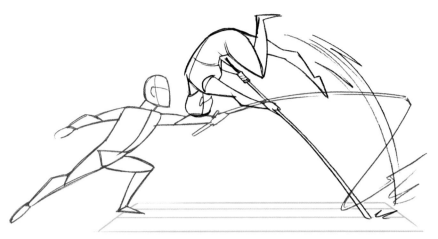

2 SELECT A POSE
Pick the pose you like the best from the ones you've sketched. In this one, the Chosen One is pole-vaulting away from a whip attack. Draw it at a wide angle to better visualize what's going on.

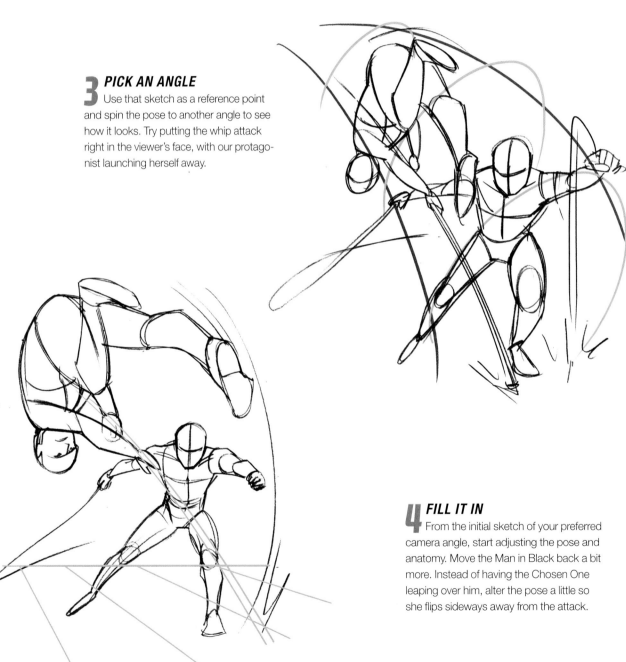

3 PICK AN ANGLE
Use that sketch as a reference point and spin the pose to another angle to see how it looks. Try putting the whip attack right in the viewer's face, with our protagonist launching herself away.

4 FILL IT IN
From the initial sketch of your preferred camera angle, start adjusting the pose and anatomy. Move the Man in Black back a bit more. Instead of having the Chosen One leaping over him, alter the pose a little so she flips sideways away from the attack.

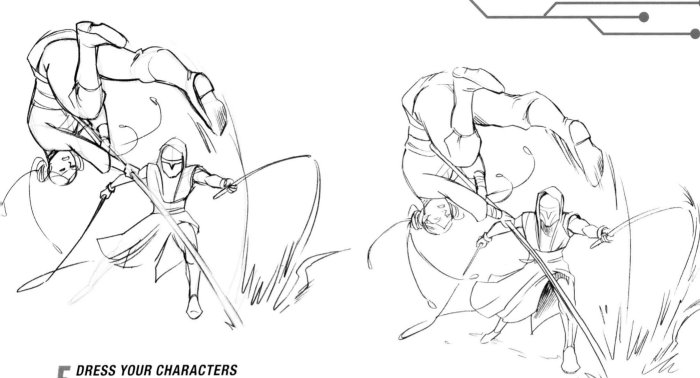

5 DRESS YOUR CHARACTERS

Start adding the clothes and details. The villain has his mask on, and his robes are swishing as he lunges forward. Our hero's braids are flailing about as she flips over. Add a slight curve to the staff as she digs it into the ground and pushes her weight on it, and show movement by adding speed lines.

6 CLEAN IT UP

Clean up your pencil lines and get ready to ink. When you do complicated poses, sketch and revise as much as you need to before you start inking. You'll save yourself a lot of time later by making sure everything is the way you want it now.

7 INK IT

Lay in your inks. Now is also a good time to refine the speed lines to emphasize movement and highlight the impact of the whip. Since it's such a forceful attack, work in some bits of debris that are launched when the whip connects with the ground.

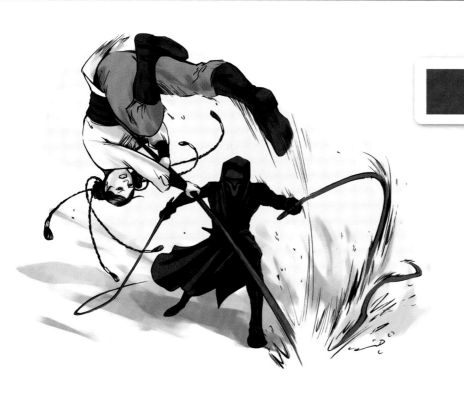

8 COLOR IT

For the duelists, all you need are the individual colors of each character. On top of that, add in a final lighting color to unify the picture. Color in everything according to your palette, then determine the direction the lighting will come from. In this case, the light source is above them, so work in the shadowed areas below.

9 ADD FINISHING TOUCHES

Add more detail to the colors and create another layer of shadows to connect everything in the scene together. Since the whips glow, make sure you draw in the light and color that emit from them. Also, blur the Chosen One and her boot a bit to imitate the effect of fast objects in photographs.

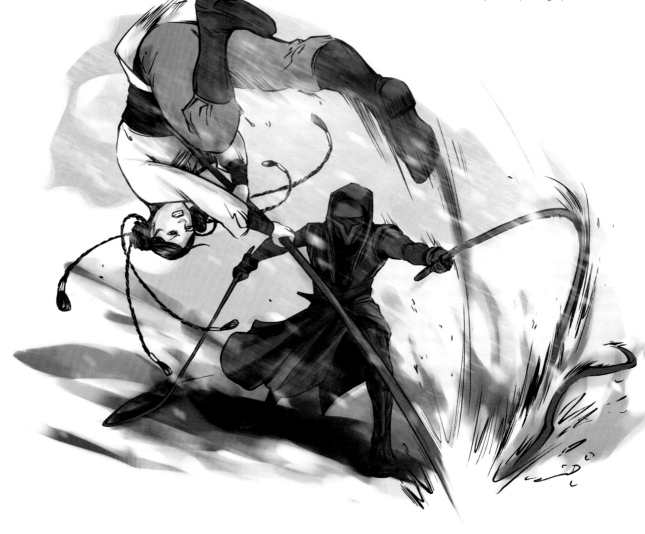

Space Western

Space truly is the last frontier; it's the one great unknown left to humanity. Like the frontier stories told in generations past about the settlers that braved inhospitable new terrain, the space western tells of a whole new kind of cowboy. The heroes in these tales tend to be anti-heroes, the stakes are a lot smaller, and though the setting is an alien planet, it looks more like the streets of a dusty town at high noon than the polished halls of a sophisticated space craft.

SPACE WESTERN PALETTE

Choose a palette with a lot of neutral tones for your space western. You're looking for colors that are a bit dirty and not very regal.

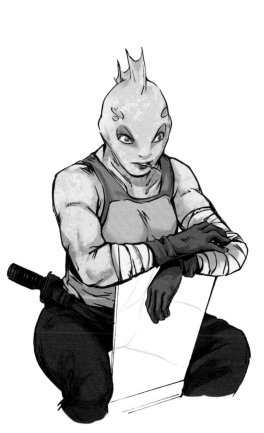

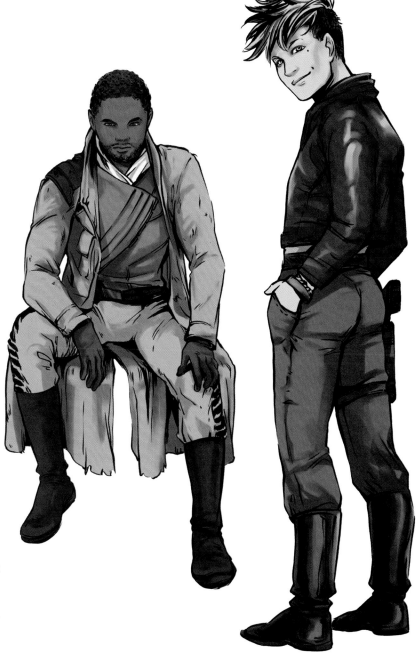

ROGUES, SMUGGLERS AND BOUNTY HUNTERS

Space westerns are overflowing with ne'er-do-wells. While you design them, keep a few simple tips in mind. For your main aesthetic, aim for a classic western look, complete with boots, dusters and clothes that look worn from the trail. But remember, this is a science-fiction world. There should be aliens among your humans and high-tech gadgets in place of old-fashioned shooting irons.

Posture

The types of characters you see in a space western don't overlap much with the sort you'd expect in the clean, cold environment inhabited by a starship crew. There are a lot of different ways to get across those differences, but one of the easiest (and most effective) is to adjust your character's posture.

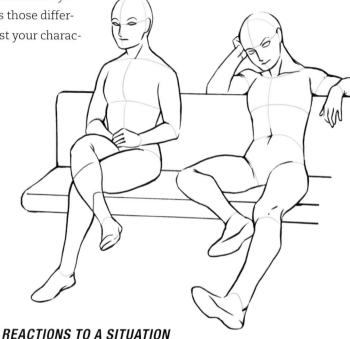

REACTIONS TO A SITUATION

Posture can help show a character's personality, but it can also show the way the same character reacts in different situations. Try drawing a bored character who's seated and waiting for a friend. Now try drawing the same character, still seated, but waiting to be called in for a job interview. What changes did you make?

PERSONALITY DIFFERENCE

These two men have exactly the same height and build, but the way they're standing sets them apart even before you add clothes. The man on the left has a rigid posture, with a straight back and his chin up. The man on the right is slouching; his spine is curved, and he's relaxed. Take a good look at both of them, and think about what assumptions you might make based on their posture alone.

EVERYDAY ACTIONS

You can use posture to imbue personality into everything your character does. Walking, running, fighting, eating, reading a book—every act your character performs will have physical tells that can show the viewer something about them. Sketch a character running, then sketch the same character running a different way. What does the pose say about the character in each case? Which is closer to the idea you want your viewers to take away?

Designing Your Crew

Start designing the crew for your space western. They won't be as groomed and polished as the starship crew; in fact, chances are they won't have any sort of uniform at all. Feel free to create mismatched outfits and disparate characters; part of the fun of this particular subgenre is watching the way very different personalities come together to work as a group.

START WITH SILHOUETTES

To make sure your crew look dissimilar from one another and to create some visual interest, start designing them as just silhouettes. Make sure they have different forms and sizes; it will help your visual storytelling if the characters are clearly distinguished from each other. The viewer will never be confused about who they're looking at, even in a scene with poor lighting, or if the character is skulking in a dramatic shadow.

Put Personality Into Your Designs

While you're designing your characters, remember to tell the viewer something about them in the design itself. Make sure your viewer can take away an impression with only a glance. Take a look at these character designs. What kind of people do you think they are? What can you say about them based on their expressions, clothes and body language? What can you say about the crew as a whole or the kind of environment they live with daily on the ship?

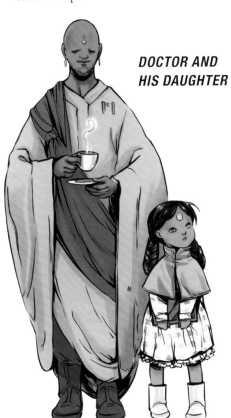

DOCTOR AND HIS DAUGHTER

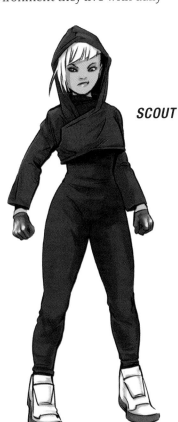

SCOUT

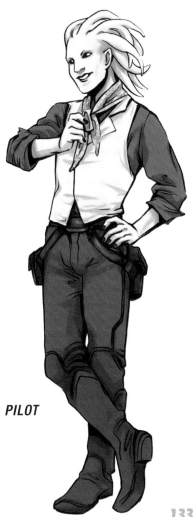

PILOT

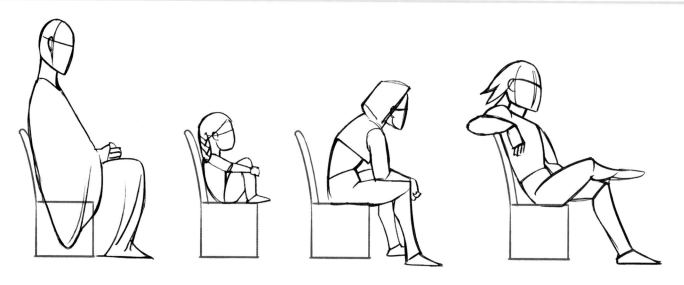

THE SITTING TEST

Another easy exercise you can use during character creation is the sitting test. First draw a single chair; you'll use the same one for every character. Then, based on personality, change the way the characters seat themselves. What do their actions say about them as a character?

Wild, Wild West

For your space western, start with the idea of a classic western and bring it forward into something futuristic.

OLD-FASHIONED ENTERTAINMENT

Mingle an old-timey game like hoop trundling with a more sci-fi aesthetic; nothing will catapult an old children's game into space faster than the addition of an alien playmate.

SCHOOLMARM

This teacher looks like something out of a classic western, but her schoolbook is decidedly high-tech.

OUTLAW

Feel free to go full-on Wild West occasionally. Not every character needs something high-tech to clue the viewer in that it's sci-fi. If they're surrounded by enough hints in the setting and designs of the other characters, the odd exception is fine.

SHERIFF

It's OK to showcase the science-fiction aspect of your world with subtle tweaks to the costumes. Instead of the standard sheriff's outfit, give the design a bit more of a modern look and upgrade his weaponry.

BLACKSMITH

Think about what sort of aliens would have an easier job at certain occupations. A creature with big, brawny arms might find black-smithing a lot easier than humans do.

SHEPHERD

On a distant planet, the plants that a farmer grows and the animals that a shepherd tends probably won't be the same types of plants and animals we have on Earth. Put some thought into the local flora and fauna, especially if one of your characters has to look after them.

FARMER

Another good way to mesh these opposing aesthetics is to design an outfit that's completely old-fashioned, then swap the average, ordinary human out for an alien.

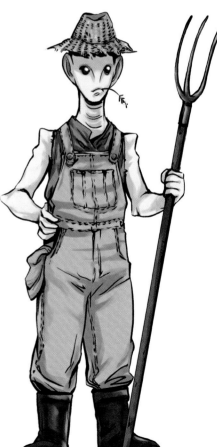

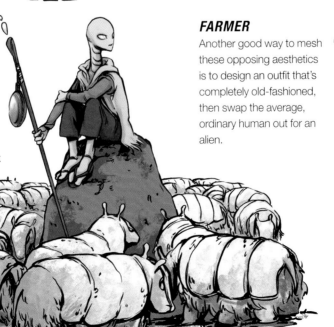

THE SMUGGLER CREW

Their ship may be small, and their paydays may be few and far between, but the Smuggler Crew is scrappy, resourceful and darn good at what they do. They act more like a family than coworkers, with plenty of easy banter and good-natured ribbing, and if any one of them is in trouble, you can bet the others will be there to bail them out. They know how to work hard and how to party hard in their downtime.

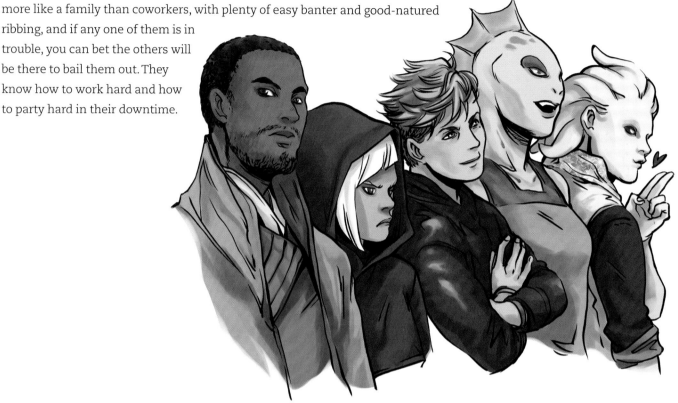

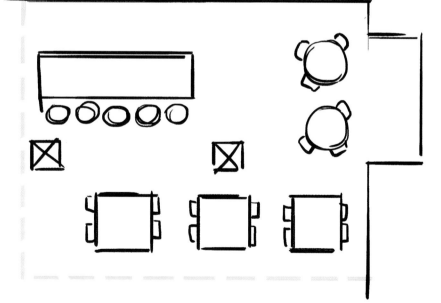

1 SKETCH THE SPACE

Start with a simple room layout. Include a few tables, chairs and the bar. Draw "X" squares where you'll place columns. The room may actually be bigger, but you only have to plan out the section you'll use for the picture. Go ahead and indicate the rest of the area with a broken line.

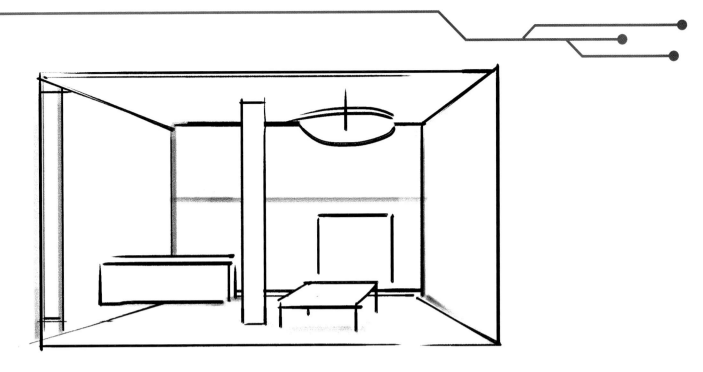

2 PICK AN ANGLE
Get a sense of the space in 3-D and start placing the large pieces of furniture in the room. Set the bar in the back, tables in the front, chandelier on the ceiling and columns where you drew your "X" squares on the layout.

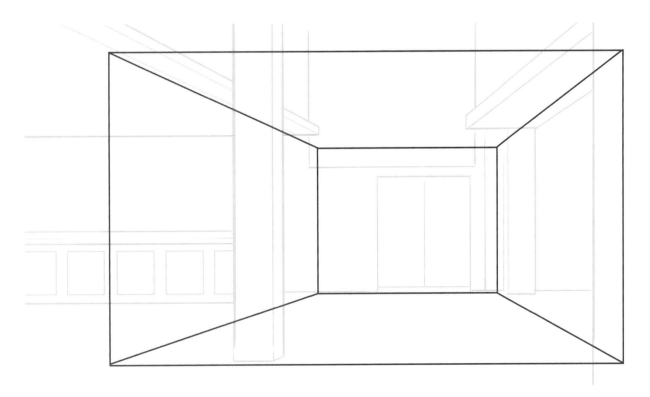

3 TRY SOME PERSPECTIVE
Use a simple, single vanishing point perspective. The room is almost a box, which makes it very straightforward, but when you're finished, it will be full of people, and you can liven it up with the characters.

4 FLESH OUT THE SETTING

Make sure your perspective is properly in place, then add some points of interest to the tables, chairs and chandelier. Work in some larger pieces of wall decor or light sconces, and start sketching where the people will go. Keep it rough for now and just use circles and a few lines to suggest a person's form. At this point, you're just making sure they're all scaled properly in the setting.

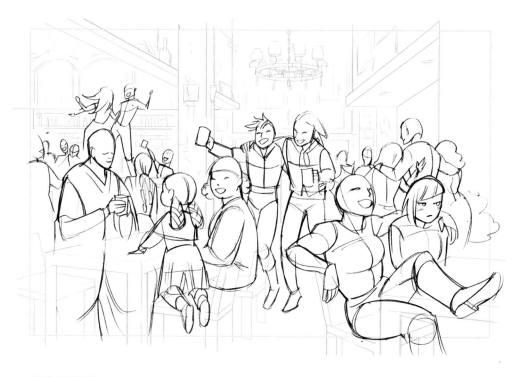

5 ADD DETAIL

Now you're ready to start putting details like expressions and movement into your characters. Try to create little vignettes involving smaller groups of people, so as you look around the drawing, you catch different things happening and notice the interactions.

6 CLEAN UP AND REVISE

This step includes the last of the work you'll need to finish before you ink your piece. Make adjustments to the costumes and poses, and add more detail to everything from the characters to the room decor. Now that you've dialed in the framework of the scene, it's time to refine it.

7 INK IT

When your art is cleaned up, ink it for that final polished look.

8 ADD COLOR

Choose the sort of colors you might find in a western saloon. You'll want to reinforce the genre here, so go for brown, camel, burgundy and gray. Color the setting in the saloon colors you chose. Your characters might branch out from these colors a little based on their personal palettes and the outfits you selected for them, and that's OK.

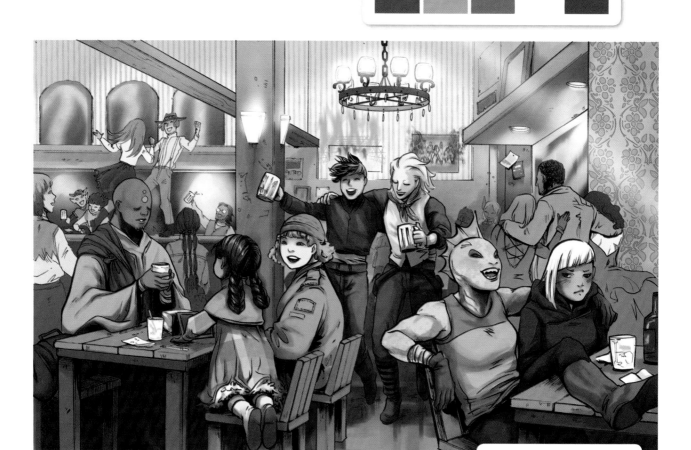

9 ADD LIGHTING AND BLEND THE STYLES

When you're finished coloring, add a futuristic vibe with the lighting. Think of the purples and blues of a modern club and really aim to give it a brighter, more modern feel. Go ahead and work in some hologram screens to show the level of technology.

When you're done, blend the two styles together until the picture is a cohesive whole. You should be left with a combination of looks: traditional Old West set off by the unexpected lighting and technology to show that you're looking at a space western.

Index

Index

About the Authors

Irene Flores is an illustrator, karaoke aficionado and serial coffee drinker. Growing up in the Philippines, Irene was heavily influenced by both Japanese animation and American comics. She and her family relocated to the United States in 1994. Irene currently works and resides in San Luis Obispo, California.

Her previous books include *Shojo Fashion Manga Art School*, its sequel *Shojo Fashion Manga Art School: Year 2*, and *Shojo Fashion Manga Art School: Boys*. She has also worked on projects and anthologies for Boom! Studios, Chromatic Press, Wildstorm, Marvel, Yen Press and Tokyopop. Visit **beanclamchowder.com** to see more of Irene's work.

Ashly Raiti is a lover of the written word in all its forms. She adores putting ideas down on paper, reading books and comic books, and discovering the unexpectedly odd. She works as a copywriter and editor. Her previous published work includes the three-volume graphic novel series *Mark of the Succubus* and a short work of fiction in *Rising Stars of Manga: Volume 3*. She can be reached at **ashly.raiti@gmail.com.**

Dedications

Irene: This book is dedicated to Ashly, because it wouldn't exist without her. It's also dedicated to my family and friends, who didn't see me for five months while I turned into a nocturnal hermit working on a book deadline. And to twenty-four-hour donut shops—you are the true heroes of the freelance illustrator.

Ashly: This book is dedicated to Irene, whose talent, determination and crazy all-nighters brought it all together. It's also dedicated to my family, my friends and a large number of very fluffy birds. You know who you are.

Acknowledgments

Thank you to the family and friends who encouraged us while we were hard at work, and to those of you who were excited to see the final product.

Thanks also to the amazing staff at IMPACT, especially our editor, Christina Richards, whose assistance and expertise made preparing this book possible. And to Sara Sydnor, who helped with color flats—you saved Irene's life!

fw
a content + ecommerce company

DISTRIBUTED IN CANADA BY FRASER DIRECT
100 Armstrong Avenue
Georgetown, ON, Canada L7G 5S4
Tel: (905) 877-4411

DISTRIBUTED IN THE U.K. AND EUROPE
BY F&W MEDIA INTERNATIONAL LTD
Pynes Hill Court, Pynes Hill, Rydon Lane
Exeter EX2 5AZ, UK
Tel: (+44) 1392 797680
Email: enquiries@fwmedia.com

ISBN 13: 978-1-4403-4902-7

Other fine IMPACT Books are available from your favorite bookstore, art supply store or online supplier. Visit our website at fwmedia.com.

20 19 18 17 16 5 4 3 2 1

Color flats by **Sara Sydnor**
Edited by **Christina Richards**
Designed by **Wendy Dunning**
Production coordinated by **Jennifer Bass**

Ideas. Instruction. Inspiration.

These and other fine **IMPACT** products are available at your local art & craft retailer, bookstore or online supplier. Visit our website at impact-books.com.

IMPACT-BOOKS.COM

- ▸ Connect with your favorite artists
- ▸ Get the latest in comic, fantasy and sci-fi art instruction, tips and techniques
- ▸ Be the first to get special deals on the products you need to improve your art